IMAGES
of America

NUNDA, PORTAGE, AND GENESEE FALLS

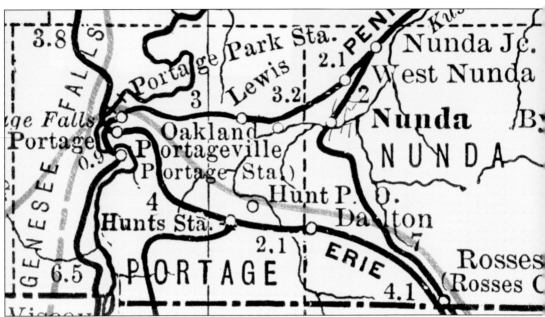

The towns of Nunda, Portage, and Genesee Falls stretch from right to left in this portion of a 1919 map of New York state by the National Map Company. The dark lines represent railroads and the lighter lines are main highways. The boundaries, names, and transportation lines are all part of the fascinating history of three important towns in the Genesee Valley. (Author's collection.)

IMAGES
of America

NUNDA, PORTAGE, AND GENESEE FALLS

Thomas S. Cook

ARCADIA
PUBLISHING

Published by Arcadia Publishing
Charleston, South Carolina

Printed in the United States of America

Library of Congress Control Number: 2010939494

For all general information, please contact Arcadia Publishing:
Telephone 843-853-2070
Fax 843-853-0044
E-mail sales@arcadiapublishing.com
For customer service and orders:
Toll-Free 1-888-313-2665

Visit us on the Internet at www.arcadiapublishing.com

Dedicated to the people of Nunda, Portage, and Genesee Falls, past and present, and to the generations to come.

CONTENTS

ACKNOWLEDGMENTS

I would like to thank the many individuals and organizations that made this book possible.

First, I am grateful for the assistance of our local town historians. Nunda's Valerie Griffing, Portage's Lorraine Rocker, and John Quinn of Genesee Falls all provided images and information found throughout the book. I also thank the following people for their help: Mary Barr, Bell Memorial Library, Jerry and Margaret Barkley, Donna Brown, Leonora Brown, Ken Buckley, William Burt, Castile Historical House, Joe Colombo, Mary Colombo, Colorado College, Brewster and Hope DePuy, Duryea family, Duryea-Kleinhenz-Lanthrop VFW Post, John Fusco, Jim Gelser, Genesee Valley Council on the Arts, David Hurd, Letchworth State Park, Archie Maker, Al Millilo, New York State Archives, New York State Museum, Nunda Historical Society, Nunda Trinity Church, Once Again Nut Butter, Charlie Ostrum, Portageville Chapel, Jesse Randall, Gail Rodgers, Tom Roffe, Joan Schumaker, Jane Schryver, Seager-Werner American Legion Post 333, Hal and Marion Seymour, Robert Smith, Katherine "Tib" Smith, Carma Bull Stone, Karen Gibson Strang, Clair "Dub" Swyers, Allen Thompson, Gerald and Alice Thompson, Bill Totsline, Town of Nunda, Village of Nunda, Ralph Watkins, and the Willett family. Special thanks go to Gail Diemoz. Gail's familiarity with the Nunda Historical Society's extensive collection, her knowledge, and her careful research on the Nunda area were indispensable. My apologies to anyone I have omitted.

I am also grateful for the wonderful historical work done by four individuals who are no longer with us: Nunda's Marjorie Frost, Dalton's Malcolm Burt, Portage's Elizabeth Thompson, and Donna Weeks of Portageville.

My wife, Anne, deserves special recognition for her patience, encouragement, and assistance throughout this project.

Finally, I would like to thank editor Rebekah Mower and the fine people at Arcadia Publishing who made this book possible. Unless otherwise noted, photographs come from the author's collection.

INTRODUCTION

Nunda, Portage, and Genesee Falls is a journey through the history of three towns in western New York state. The trip is more than two centuries long and is still being written today. It begins with Native Americans, weaves through pioneer clearings and prosperous farms, among Irish workers building the Genesee Valley Canal and the great Portage Bridge, down the busy streets of local communities, and is carried by local and national events that, along with the land itself, shaped the lives and futures of the people who have called the towns their home.

Before this journey can begin, it may be helpful to clarify some terms. First, this book uses the terms "town" and "township" interchangeably. Both refer to a subdivision of a county that has its own local government. Towns are created by an act of the state legislature. Although it is common for rural residents to say they are "going to town," they are really already in one. They are going to either a village or a hamlet. Villages are incorporated communities that have their own municipal government. Hamlets are communities that are not incorporated. So Nunda, Portage, and Genesee Falls are separate towns containing several hamlets, such as Dalton, Hunt, Oakland, and Portageville. Nunda has the only village in the three towns, which is also called Nunda.

Why put these three towns together? Each town's history merits its own book. But publishing requirements called for a combination of several rural towns, so coverage was expanded to include these three townships. There are drawbacks to this broader coverage, the most apparent being a loss of some historical depth and detail. The fit, however, is natural, and adds its own color and understanding to the story.

The first chapter, "Beginnings," explains why. The boundaries that separate the present-day towns are relatively new if one considers the long history of the Genesee Valley. For thousands of years the land was inhabited by generations of Native Americans who built their villages and camps throughout the area. By the 18th century, the entire region was the homeland of the Seneca, the "Keepers of the Western Door" of the great Iroquois League. They called the lands along the river Sehgahunda, "the vale of three falls." The Seneca left their mark on the towns in many ways. Nunda's very name, for example, came from Onondao, the major Seneca village near the present village.

When the township of Nunda was formed in March 1808 it stretched for nearly 300 square miles across the Genesee Valley. As the settlement of the frontier town progressed, population growth encouraged the division of "greater" Nunda into smaller towns. By the time this process was over, nine towns were found within Nunda's original boundaries, including Portage (1827) and Genesee Falls (1846.)

Even after the three towns separated, Nunda, Portage, and Genesee Falls remained connected in many ways. The construction of roads, the opening of the canal, and the building of railroads maintained geographic and economic links among the towns, while families, churches, schools, and organizations overlapped town boundaries. Although now in different counties (Nunda and Portage joined Livingston County in 1846 and Genesee Falls was annexed to Wyoming County

that same year), parts of all three towns share the same school district, phone exchange, and overlapping fire districts. But at the same time, each of the towns developed their own identities and wrote their own histories. This book explores each of those stories in the middle chapters.

Chapter 2 traces the development of the town of Nunda from the 1850s to the 1950s. The first half of this period was the heyday of the town, with the Genesee Valley Canal, railroads, and growing road systems encouraging the growth of business and industry. Economic growth led to social and cultural development of both the village of Nunda and its young rival, Nunda Station (Dalton). The chapter also illustrates how the changes and challenges of the 20th century provided both problems and opportunity for the town.

Portage is visited in Chapter 3. The town had nearly 5,000 people in 1840, almost double that of nearby Nunda. But the majority of this number was engaged in building the Genesee Valley Canal. When the canal was completed, Portage's population dropped by almost 75 percent. This was not a disaster for the town. On the contrary, it was necessary, for Portage was a place that would have made Thomas Jefferson proud. Jefferson saw the ideal America as an agrarian nation, a land of stalwart farmers on family farms supported by small communities of craftsmen, small manufactories, and local merchants. This was Portage in its heyday, and Chapter 3 takes a historical tour through the town.

Genesee Falls was once noted as the "liveliest place for its size in Wyoming County." As Chapter 4 shows, its history is quite "lively" too. Ever since the first pioneers arrived, the story of the town and the community of Portageville has flowed along much like the Genesee River that forms the town's eastern border—sometimes boisterous and strong, often quiet and steady, but always moving and changing. Portageville has been an important mill town, a manufacturing center, a self-sufficient community of churches, proud homes, and flourishing small businesses, as well as a bustling tourist town with hotels, saloons, and more. Through these changes and despite devastating floods, fires, a historic tornado, and the threat of sinking under a man-made lake, the people of Genesee Falls have brought their town into modern times.

These modern times are the subject of the last chapter. The last 60 years have not been kind to small towns. Vast economic, social, and cultural changes that are intensified by new technology and world events have posed great challenges to Nunda, Portage, and Genesee Falls. The past decades have seen the closing of crucial businesses, the loss of local landmarks, and a changing attitude toward many aspects of rural life. Yet despite problems, the people of these three towns have continued to celebrate the past and build their future as they participate in the daily life of their towns.

Some readers may search in vain for stories of local individuals and families. Although some appear, they are only a small percentage of the people who have lived in these three towns. Even some of the area's nationally known figures have been left out, such as Nunda's Andrew J. Russell, a local painter and photographer of the Transcontinental Railroad, or Portage's Clayton White, a popular vaudeville star, or Genesee Falls' Victor Selden Clark, a renowned educator, journalist, author, and economist. What should be remembered is that the history of the towns shown in this work is a result of the lives of all the inhabitants. Although all are not named nor their faces shown, they are reflected throughout this book.

Nunda, Portage, and Genesee Falls is not intended to be a complete history of these three remarkable towns. It is hoped that this book will encourage the reader to dig deeper into the area's past and take an active role in preserving the history that they find.

One

BEGINNINGS
1800–1850s

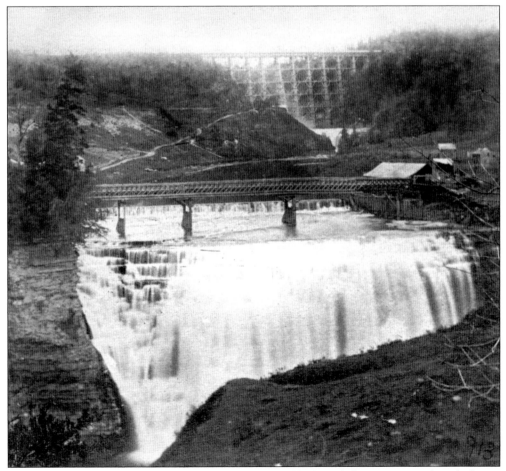

The Seneca once called this waterfall Skagadee and believed the sun stopped each day to admire its natural beauty. By 1860, as shown in this early image of the Middle Falls, the area had been reshaped by those who settled the new towns of Nunda, Portage, and Genesee Falls. The transformation of the land from a frontier wilderness to prosperous farms and communities is where the story begins.

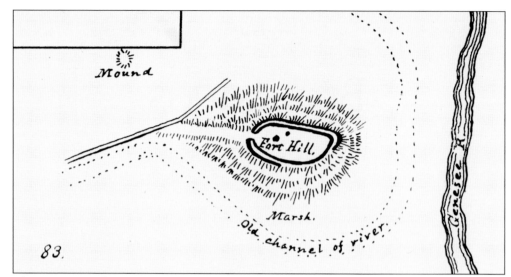

The Genesee Valley was shaped by the glaciers that covered the land. Since the last Ice Age, countless generations of native people inhabited the valley leaving behind settlement sites and artifacts. One fortified village site, perhaps 1,000 years old, was located on a small hill south of Portageville. Fort Hill is shown in this 19th century map by John S. Minard. (New York State Museum.)

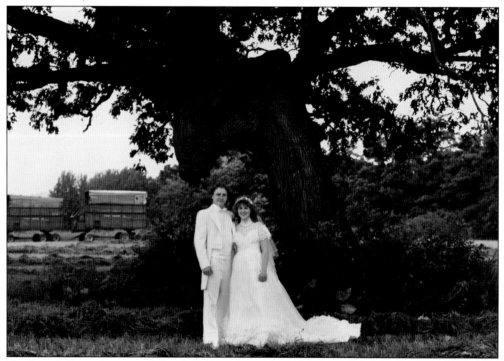

Newlyweds Brett Pierce and Carol DePuy pose in June 1982 at Nunda's Moose Tree. Legend says this unusually shaped tree was a Seneca trail marker used when they settled the village of Onondao. Numerous artifacts, names such as Nunda (meaning "the meeting of the hills"), and the Moose Tree are reminders of the area's native history. A storm toppled the tree later that year. (DePuy family.)

Skadyohgwadih, or Philip Kenjockety, was born in Onondao in the early 1770s. He was a young boy when the Sullivan Expedition invaded the region during the Revolutionary War. Onondao was missed by the invaders and became a refugee center for Seneca from other villages. Kenjockety and the other Seneca drifted away from Onondao after the 1797 Treaty of Big Tree. He died on the Cattaraugus Reservation in 1866. (Nunda Historical Society.)

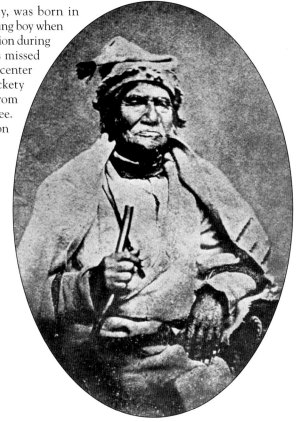

On March 11, 1808, the New York legislature organized northern Allegany County into the town of Nunda, which encompassed all the land shown in this 1829 map. As population grew, new towns were created from Nunda's original lands. Most of the lands west of the Genesee River left Nunda in 1818. Nine years later, the town of Portage was formed. Genesee Falls was formed from Portage and Pike in 1846. (Nunda Historical Society.)

Settlement began before Nunda was formed. John, Samuel, and Seth Fields arrived south of Portageville in 1804, followed by others in the western part of the future town. Jacob Shaver began permanent settlement east of Genesee in 1810. It was not until 1817 that James Paine bought the first land in the present town of Nunda. This 1919 photograph shows the valley south of Portageville. (New York State Archives.)

The first challenge was to clear the land so that crops could be planted. Nothing was wasted in the pioneer's world. Trees provided logs for building, wood for fuel, and ashes for the settler's first cash crop of potash. Later, the stumps would be pulled and made into fences. John Weaver took this 1950s photograph of a surviving stump fence near Barkertown in the town of Nunda. (Nunda Historical Society.)

The first town meeting was held at the home of Peter Granger in April 1809. Town "clark" Asahel Trowbridge recorded the minutes in the town's first book, which is still kept by the Nunda town clerk today. The minutes, shown in part here, provide a glimpse of local government on the frontier. The pioneers elected a town supervisor, tax assessors, two constables, a (tax) collector, overseers of the poor, commissioners of schools, fence viewers, damage prizers, pound keepers, and 10 pathmasters. Two ordinances were also passed: "No hogs to run at large" and "Town bounty on wolves $3." Eli Griffith, the first town supervisor, and two others at the meeting later died in the War of 1812. At the time of the meeting, the town had fewer than 500 inhabitants. By 1814, the number had doubled. (Town of Nunda.)

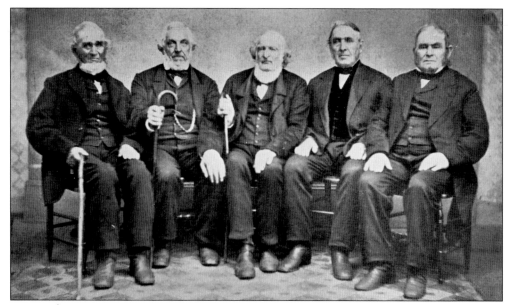

Transportation was important from the earliest days. Today's River Road in Portage follows a pre-1800 wagon road. Pioneers were hired by the state in 1824 to cut another road from Mount Morris to Angelica. They included pioneers, from left to right, Noah Warren, George Merrick, Nathaniel Clough, Silas Warren, and Jonas Warren. Modern Route 408 follows this pioneer road and is still called State Street in the village. (Nunda Historical Society.)

Log cabins were the pioneers' first homes. Mistakenly identified on a postcard as the home of Seneca captive Mary Jemison, this cabin actually belonged to the Everett family. It once stood near the Castile entrance to Letchworth Park. As soon as possible, settlers built frame houses with lumber from local sawmills. By 1855, only nine percent of the homes in the three towns were still made of logs.

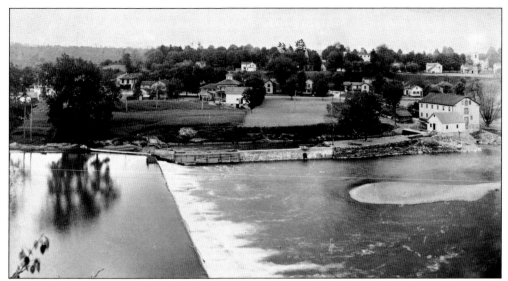

Mills were essential to pioneers. The 1824 *Gazetteer of New York State* recorded 11 mills in what was then Nunda. Most were sawmills, but several gristmills and a fulling mill were also listed. Seth Smith and his partners established a major mill site along the Genesee River at Portageville before 1820. Pioneer businessman George Williams later acquired these extensive mill works. The milldam and race were still visible in this c. 1910 photograph.

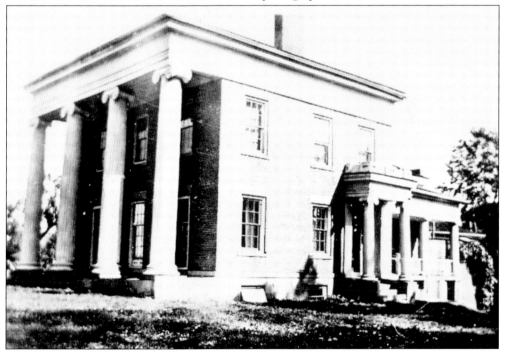

Col. George Williams arrived in the area in 1816 as a land agent on the Cottringer Tract. A War of 1812 veteran, Williams became a major developer in the area. His success is seen in the home he built overlooking the Genesee Valley. Williams died in 1874 and was buried in the family cemetery that is still visible from Short Tract Road. His mansion and several barns burned in May 1934. (Joan Schumaker.)

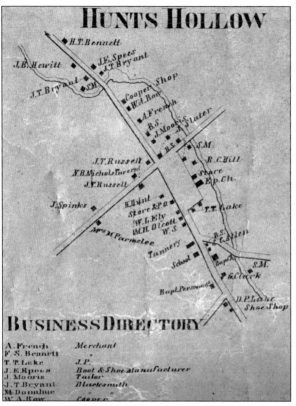

HUNTS HOLLOW

H.T.Bennett
J.B.Hewitt
J.E.Spees
J.T.Bryant
J.T.Bryant
S.M.
Cooper Shop
W.A.Roy
A.French
B.S.
J.Mook
Slater
B.S.
S.M.
J.T.Russell
R.C.Hill
N.B.Nichols Tavern
Store
J.T.Russell
Ep.Ch.
J.Spinks
H.Hunt
Store & P.O.
T.T.Lake
W.L.Ely
W.H.Olcott
Mrs.M.Parmelee
W.S.
B.S.
C.Allen
Tanners
School
Bapt.
S.M.
G.Clark
Bapt.Personage
D.P.Lake
Shoe Shop

BUSINESS DIRECTORY

A.French — Merchant
F.S.Bennett — "
T.T.Lake — J.P.
J.E.Spees — Boot & Shoe Manufacturer
J.Morris — Tailor
J.T.Bryant — Blacksmith
M.Donahue — "
W.A.Roy — Cooper

Several settlements had taken shape in greater Nunda by the 1820s. Along with Schuyler (now Portageville) west of the river, Wilcox Corners, Cooper(s)ville, Barkertown, Nunda Valley, Messenger's Hollow (later Oakland) and Hunts Hollow appeared east of the river. Once known as Kishawa, Hunts Hollow took its name from Sanford Hunt, who arrived in 1819. Hunt owned a sawmill, ashery, and store, and he ran the post office. This map is from 1858.

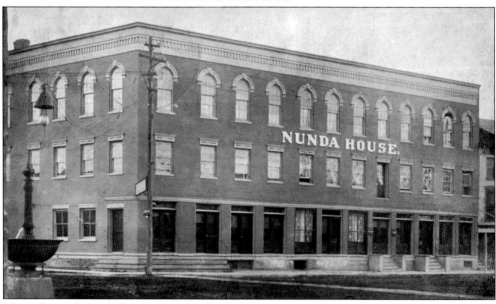

The village of Nunda began as Hubbell's Corners. Named for pioneer Alanson Hubbell, the settlement became Nunda Valley when the post office was located there in 1831. Within a decade, the new village square was lined with buildings. One was the Nunda House built by William and Carlos Paine. Located on the site of Hubbell's tavern, the brick hotel hosted Nunda's first formal social gathering on New Year's Day in 1836.

Schools and churches appeared during this time. Although not the first, the Wisner School shown here has an interesting history. Established before 1830, the schoolhouse was where the First Presbyterian Church of Nunda organized in October 1831. The school, now a home, stands on the corner of DeGroff and Myers Roads. This photograph was taken around 1940 when centralization led to the closure of most district schools. (Nunda Historical Society.)

The Presbyterians built their first church building in 1834 on the northwest corner of East and Church Streets in what was then Nunda Valley. They sold the building in 1846 to the Methodists, who moved it on logs across Church Street to its present location. The First Methodist Church, shown here in the late 19th century, is the oldest standing church building in the three towns. (Nunda Historical Society.)

Genesee Valley Canal
Celebration
At Nunda Valley, May 11, 1836.

Order
of the
DAY.

1st. *National Salute*

At sun rise, and ringing of the Bell. 2d. The citizens will form procession at the Nunda House, under direction of Col. Wm. HUFMAN, Marshall, at the ringing of the Bell at 1 o'clock P. M., and march (with the Boat and Music at the head) to the Presbyterian Meeting House.

3d.

Music, By the Band or Choir.
4th.
Address, by *A. C. Chipman*.

5th. *AIR*—The Campbells are coming, by the Band—and ONE GUN.

6th. Procession form and march to the Nunda House to dine at 3 o'clock P. M.

7th.
Speeches, Toasts, Guns, &c.

By order of the committee of arrangements.

H. C. JONES, CHAIRMAN.

Nunda and Portage residents celebrated when news reached them that the state legislature approved the construction of a canal from Rochester to Olean. The Genesee Valley Canal would connect the area with the Erie Canal to the north and the Allegheny, Ohio, and Mississippi Rivers to the south. Work soon began, but it was almost 20 years before the first canal boat arrived. (Genesee Valley Council on the Arts.)

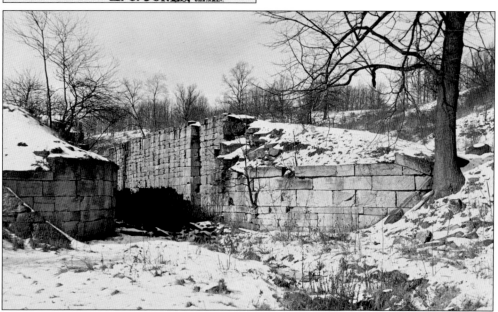

Building the canal in the Nunda and Portage area was not easy. Seventeen locks were needed to take the canal out of the Keshequa Valley onto the Portage highlands, where hundreds of Irish workers dug the "deep cut." This 1950s image by John Weaver shows the ruins of a lock in Oakland. Although this lock is gone, several others and the Deep Cut are still visible along the Genesee Valley Greenway. (Nunda Historical Society.)

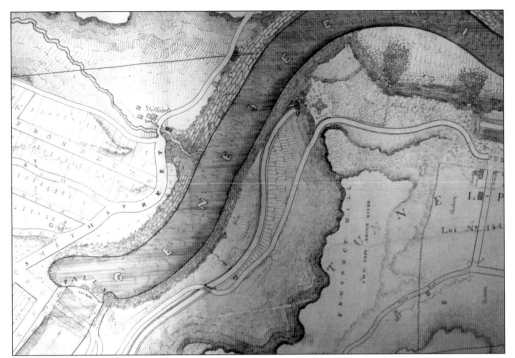

The greatest challenge was a 1,000-foot tunnel that was to be dug through a ridge overlooking Portage Falls. This 1840 map commissioned by George Williams anticipated a bustling village at Middle Falls once the canal was completed. The canal is shown passing through the proposed tunnel in the upper right. Neither the tunnel nor "Portage Falls Village" materialized. Middle Falls appears on the lower left. (Letchworth State Park.)

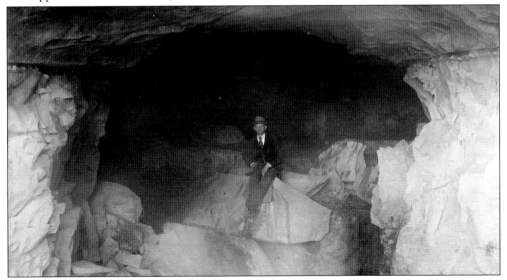

Work continued on the Portage Tunnel from 1837 to 1842, when state financial problems brought construction to a halt. When work resumed in 1847, engineers decided that the tunnel was not feasible and abandoned it. Here, tourist Arthur M. Sisson sits on fallen rock in the partially completed tunnel in September 1898. The "Bat Cave," as it was later called, is no longer accessible to visitors. (Karen Gibson Strang.)

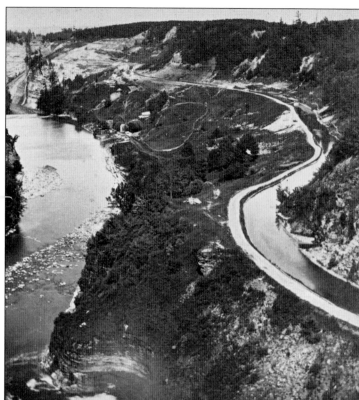

Although the tunnel was abandoned, work continued on the canal. The first boats floated through Nunda and Portage in 1851. This 1870s image, looking north from the Portage Bridge, shows the canal along the eastern bank of the wider Genesee River. In the distance, one can see where the canal was pinned to a man-made ledge on the cliff. Today, Trail No. 7 follows the old canal through Letchworth State Park.

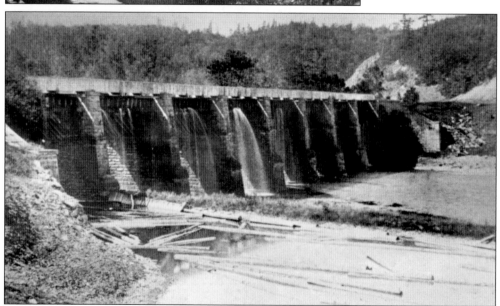

The canal crossed the Genesee River at Portageville. Standing on stone abutments, the aqueduct carried the canal along a 400-foot-long wooden trough. Built for $70,000, it was one of the most expensive features on the canal. The aqueduct was a constant source of water loss on the canal and was frequently under repair. Some piers and the far wing wall visible in this early photograph still stand today.

Around the time canal boats arrived in the area, work began on a railroad trestle across the Portage gorge. Completed in 1852 by the Buffalo & New York City Railroad, the Portage High Bridge cost $175,000 and the lives of several Irish workmen, including John Hanely and Edward Dewire. They were swept to their deaths over the Upper Falls, which is shown in this early photograph of the completed bridge.

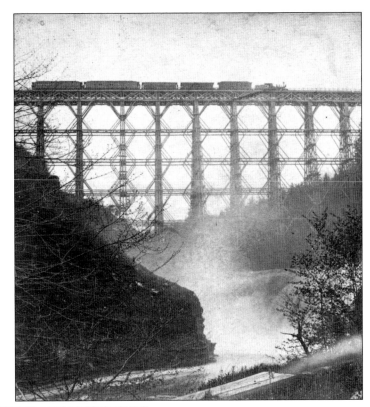

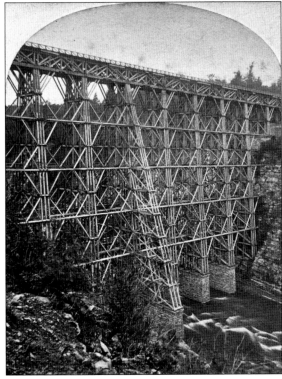

An 1853 British engineering journal stated, "The highest timber bridge in the world affords a proof . . . of the energies and talents of the engineers of the United States, and their go-a-head manner of constructing works of magnitude in a very short space of time, and at a minimum cost." Part of the Erie Railroad after 1856, the Portage Wooden Bridge was a popular attraction until 1875. (Karen Gibson Strang.)

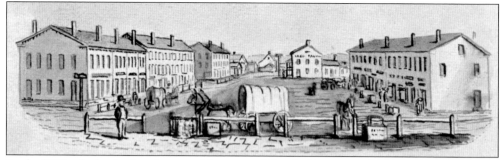

By the 1850s, the beginning chapter of the story of Nunda, Portage, and Genesee Falls had come to an end. What was once a frontier was now a land of expanding farmlands and bustling villages such as Nunda Valley. This 1840s sketch shows the village square with Merchants Row to the right and the Farmers Exchange to the left. Many of these buildings, erected around 1834, still stand in Nunda.

The settlement era was over, but aspects of frontier life lingered for generations. Once a necessity to pioneer farmers, ox teams were rare by the late 1800s. According to the *Dalton Historical Cookbook*, however, Lewis Parks's team from Granger was a common sight into the early 20th century. This real photo postcard, labeled "Last Ox Team" shows Parks and his oxen in front Gephart's Studio in Dalton. (Nunda Historical Society.)

Two

NUNDA
1850s–1950s

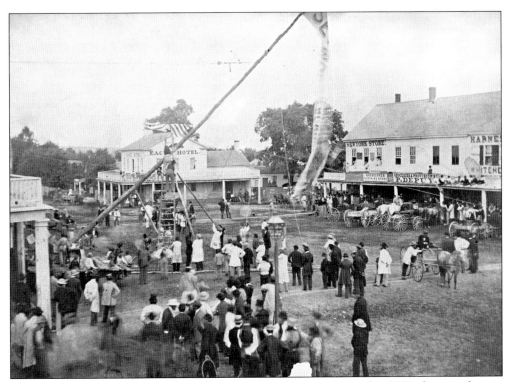

Many of the Nunda residents who gathered in the village square in this 1868 photograph were descendants of pioneers. They and their descendants would experience Nunda's golden age—the century after the canal and railroad opened. In this political flag raising, almost all the participants are male. Women's suffrage was just one of the many changes Nunda would experience in the century to come. (Town of Nunda Historian's Office.)

Nunda had become a manufacturing center by the 1850s. Local workshops produced everything from hoop skirts and knives to wooden pumps and furniture. The wagon shop of Francis Gibbs, shown here, produced carriages and coaches described as "the wonder of the time." The Nunda Lumber Yard razed the building on south State Street in the summer of 1954. Gibbs Street was named for this early manufacturer. (Town of Nunda Historian's Office.)

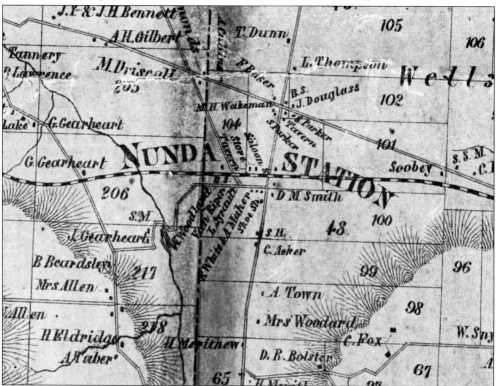

Gibbs and other businessmen only had to transport their goods to the new depot at Nunda Station to reach distant markets. Although the railroad had been built only six years earlier, this 1858 map shows that a new community was taking shape around the railroad station. The depot took on added significance in 1861 when the Civil War began.

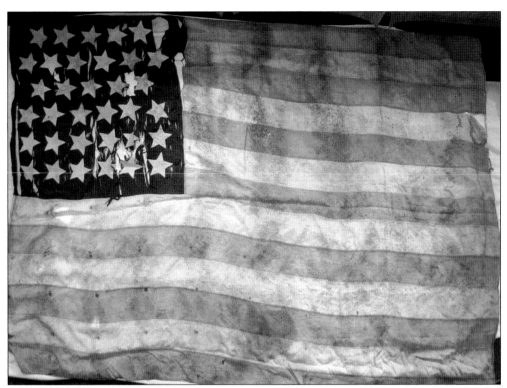

Company F of the 33rd New York Infantry was the first of five infantry companies from the area. When they finished training in the village square, they marched to Nunda Station carrying this flag, presented by local ladies. The flag survived the war and returned to Nunda but many Company F soldiers did not. The flag was found in a time capsule in the old Presbyterian Church when it was razed in 1979. (Nunda Trinity Church.)

John J. Carter was among the first of nearly 300 men to enlist from Nunda. A Nunda family took him in after his Irish immigrant parents died. Carter was training to become a teacher when the war broke out. He won the Medal of Honor at Antietam and rose to the rank of captain. This portrait hangs in the Carter Memorial Building. (Seager-Werner American Legion Post 333.)

After the war, John Carter married Francis Gibbs's daughter Emma and moved to Pennsylvania and opened a haberdashery. He soon entered the oil business and by 1893 had founded the Carter Oil Company. Although wealthy and powerful, Carter never forgot Nunda. He returned to his hometown in 1906 to build what is considered one of the finest surviving examples of Grand Army of the Republic buildings in New York state.

Many Civil War soldiers are buried in Oakwood Cemetery. Among them are John Emmons, who died of camp fever at age 15; talented teacher William Cosnett, who was killed at Fredericksburg; and Richard Gay, a North Carolina slave who ran to the Union lines to gain his freedom. Area residents dedicated Oakwood's Soldier Monument in 1897. Memorial Day ceremonies are still held at the monument, shown here around 1910. (Nunda Historical Society.)

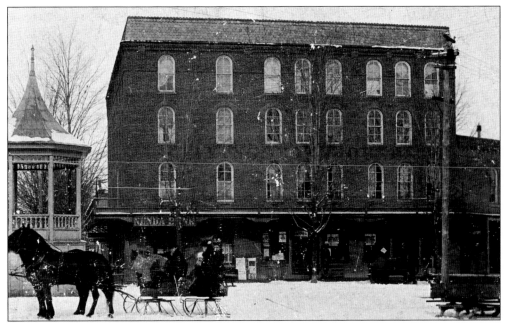

New commercial buildings appeared after the Civil War. The first and largest was the brick Livingston House complete with a two-story ballroom. The new hotel, shown here in the 1890s, was built on the site of the Eagle Hotel (page 23). The Eagle was moved down East Street on logs and eventually became the Nunda Furniture Store. The Eagle was torn down in 1981.

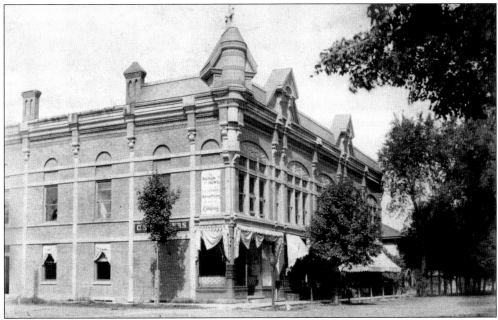

The Union Block was built in 1882 by local businessmen led by newspaper editor Chauncey K. Sanders. Described at the time as one of the most elegant commercial buildings around, it held five stores on street level with the *Nunda News* offices, a photograph studio, and other businesses upstairs. In later years the post office, Stanton's grocery, Duncan's Dry Goods, and other businesses occupied the storefronts. (Town of Nunda Historian's Office.)

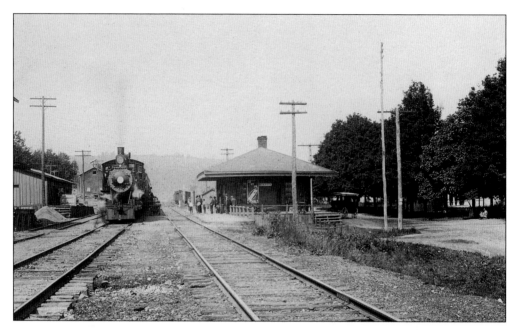

As the village of Nunda grew, so did Nunda Station to the south. Both passenger and freight trains stopped at the busy station, shown above around 1905. Nearby warehouses held the increasing quantities of products being shipped out on the Erie Railroad. Lyman Ayrault's warehouse, shown below, later the Burt Seed Company, was one of the largest. An 1877 letter to a local newspaper announced that the station's streets were "literally thronged with farmers' apples, and piled upon the green by Ayrault's and Lowell's warehouses you could see upwards of seven thousand barrels awaiting shipment . . . Nunda Station is the produce market for the whole of Northern Allegany . . . Among our manufactories we have the York Feed Cutter Manufactory, Prices Excelsior Broom Manufactory, Harness, Shoe and Blacksmith Shops." A rivalry soon grew between the two communities. (Above, Jane Schryver; below, John Fusco collection.)

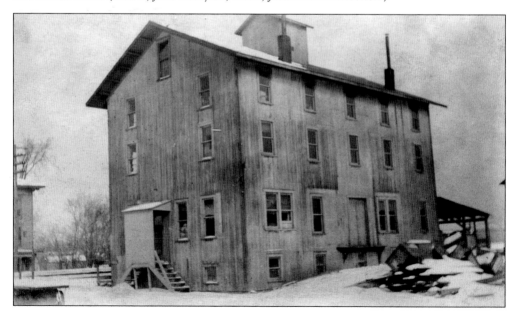

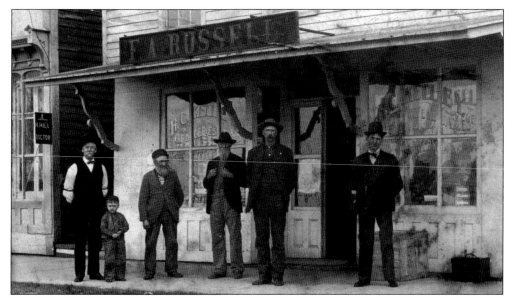

By the time these residents gathered in front of H.C. Kelley's Groceries and Bakery located in F.A. Russell's Main Street building, the name of the station and local post office had changed to Dalton. The name was chosen at a community meeting in December 1880 when local veterans suggested the name in honor of a Georgia town whose hospitable residents had impressed them at war's end. (Archie Maker.)

The Rochester, New York and Pennsylvania Railroad reached Nunda four years before the canal was abandoned in 1878. The company added a line from the village to the Erie Railroad near Swain in 1883. Swain's Branch, shown here in a Frank Hewitt photograph, closed in 1903, but train service continued to the village until the 1960s. Hewitt took this image from the old stone quarry, now the water plant.

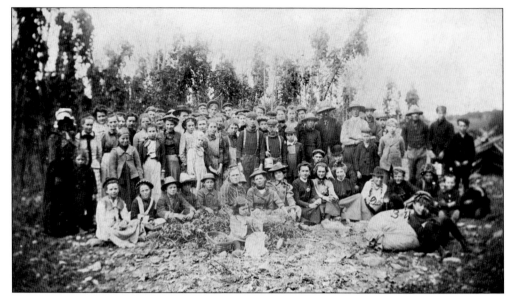

Nunda farms tripled in size between 1855 and 1875. Among the many crops grown was a new one, hops. More than 100 acres on East Hill were dedicated to hops and farmers hired dozens of local women and children, such as these workers on the Wells Paine farm around 1870, to harvest them. In September 1876, pickers held their annual "hop" dance in the Livingston House ballroom. (Nunda Historical Society.)

Faster and cheaper access to markets led to the expansion of the dairy and poultry industries in Nunda. Several cheese factories operated in the town, including this one in the village on East Street. By 1907 this factory, owned by Young and Young and operated by cheese maker B.P. McCormick, was producing 250,000 pounds of cheese a year. (Nunda Historical Society.)

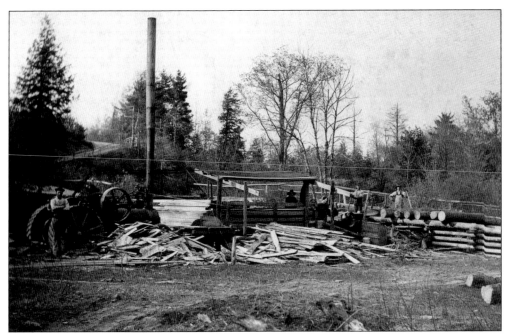

Although much of the original forests were gone, sawmills maintained their presence throughout the town. Now powered by steam engines instead of water wheels, they moved to the remaining stands of timber. This 1890s photograph shows local carpenter and builder Sheldon Green and his crew working in Wild Cat Gully near the northeastern part of the town. Sheldon and his father, Husted, had been born in a nearby log cabin. (Gail Diemoz.)

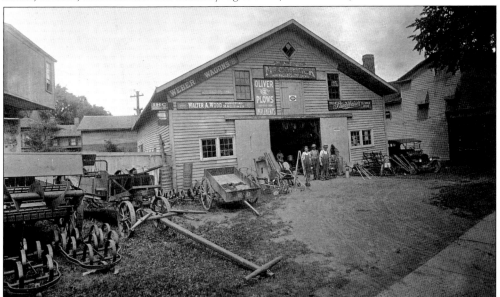

Local farmers were able to buy a wide range of farm equipment from Welcome "Welly" L. Paine's business on East Street, right behind the Livingston Block. Like many prominent businessmen of his day, Paine was active in the community, serving as tax collector and president of school District No. 1. He was a great-grandnephew of pioneer James Paine and his grandfather built the Nunda House. (Nunda Historical Society.)

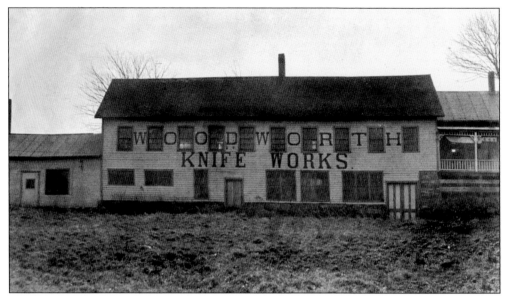

Blacksmiths Charles and James Woodworth set up their forge in 1849 and did a brisk business with area farmers. A Civil War wound cost Charles his left hand, but after designing special machinery, he established the Woodworth Knife Works in 1876. Later joined by his son Fred, the factory produced quality knives well into the 20th century. The factory on Woodworth Lane became a dwelling in 1962. (Nunda Historical Society.)

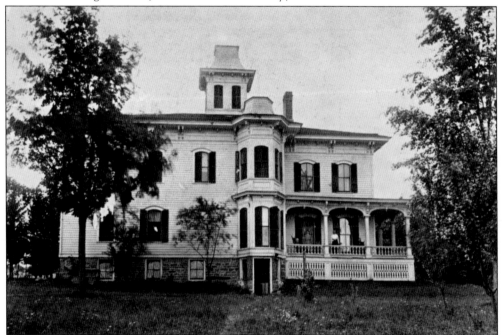

Landowner Daniel Passage discovered a spring on the hillside south of the village after the Civil War. When testing showed the water was rich in minerals, he built the Passage Water Cure, shown here in 1881. The structure was later known as the Nunda Mineral Spring House. Although the building is long gone, the spring still flows in a field just east of Water Cure Road. (Nunda Historical Society.)

Prosperity and railroads meant travelers. Sanford Parker built a new hotel in Dalton in 1876. Located near the depot, the Parker House became a favorite stop of salesmen and travelers. In addition to a livery service and a popular dining room, the hotel hosted community events such as this 1886 Decoration Day ceremony held in its third-story ballroom. The hotel was torn down in August 1920. (Nunda Historical Society.)

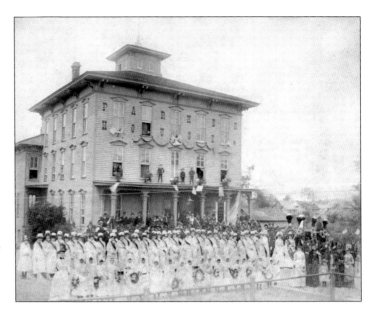

John Hughes stands in the lobby of his Hotel St. John sometime after it opened on Portage Street in 1890. According to the *Nunda News*, the hotel offered guests a reading room, parlor, dining room, and 17 sleeping apartments "lighted throughout by 58 electric lights, and every room is connected with a system of electric call bells." The building was razed for a gas station around 1940. (Nunda Historical Society.)

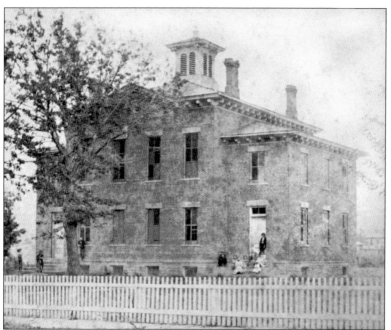

Schools grew along with the town's farms and businesses. The Nunda Academy opened its doors in September of 1867. Almost 200 students paid between $4 and $8 to enroll in the new school that fall. The building, located on Mill Street on the present school grounds, was considered by the *Nunda News* "one of the most inviting institutions of the kind to be found in any locality."

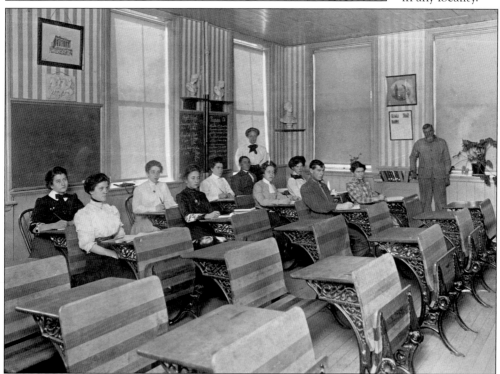

The Nunda Academy became the Nunda Union Free School in 1876 and then the Nunda High School in 1897. Teacher training classes, such as this 1914 class, were conducted from about 1883 until 1929. These future teachers are in one of the rooms of the "new" 1904 high school that incorporated the original 1867 structure as its west wing. School janitor Herbert Crego stands to the right. (Nunda Historical Society.)

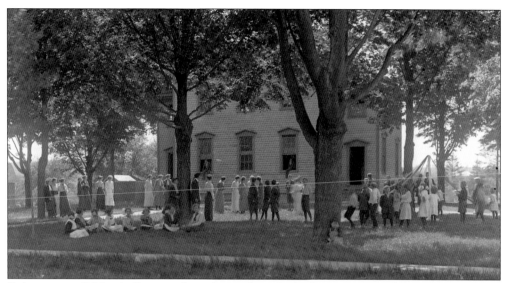

Dalton was still Nunda Station when the residents built this two-story school building on the corner of State and Church Streets. Originally only a graded school, it became the Dalton Union School in 1893 with the first class graduating in 1895. Taken from glass plate negatives, these photographs document life at the school. Since the American flag in the bottom photograph appears to have just 46 stars, the probable date of the images is between 1907 and 1912. In the above photograph, the student body enjoys some fresh air on the school's front lawn. Below, a teacher tests three students' knowledge of New York state geography as other students read at their desks. This school served the area until the new Dalton Central School building opened down the street in 1939. (Both Jane Schryver.)

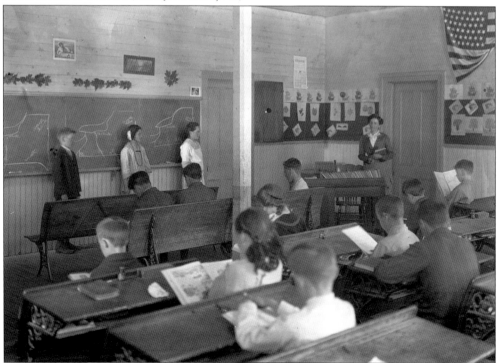

Each of the town's hamlets took pride in their one-room school. Here, the teacher and students pose proudly in front of the Barkertown School. Known as District No. 5, the school served generations of farm families. The school remained opened after Nunda's 1938 school centralization, finally closing in 1949. Descendants of the Cox family who attended the school now live in the former school building. (Town of Nunda Historian's Office.)

Many of the children who lived north of the village went to what was known as the Cooperville School. This is the second school building; the first one burned on November 14, 1893, killing teacher May Porter and little Johnny Johnson. The tragedy shocked Nunda and made headlines in the *New York Times*. The second school building still stands as part of a home on Creek Road. (Nunda Historical Society.)

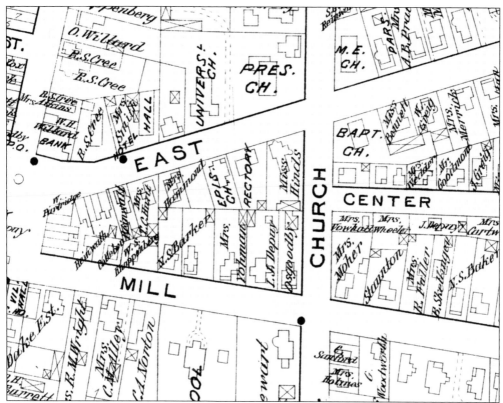

There were eight churches in the town by the 1890s. Five of them can be found on this 1902 map of Nunda village. Clockwise from upper right are the United Methodist, First Baptist, Grace Episcopal, First Universalist, and First Presbyterian Churches. Methodist churches were also built in Dalton and Barkertown. For many years, East Street churches celebrated Sundays by ringing their bells, each in a prescribed sequence. (Bell Memorial Library.)

Irish canal workers brought their Catholic faith to the town in the 1840s. By 1854, they established the Holy Angels Parish and built a new church on Church Street in 1872. Although the church was far from the cluster of larger Protestant churches, the Irish Catholic population overcame early prejudice to become an important part of the community. This photograph shows the church in 1958. (Nunda Historical Society.)

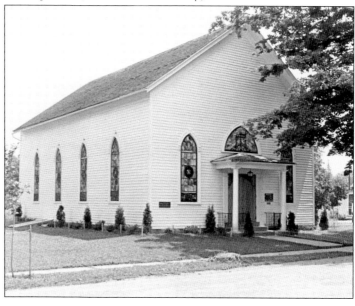

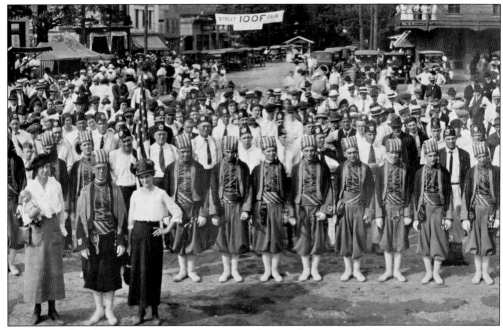

A variety of local organizations became a critical part of community life. Dozens of these clubs and societies formed, flourished, and faded over the years. Nunda's Political Equality Club, for example, pushed for woman's suffrage. Fraternal organizations such as the Masons and Odd Fellows had a significant impact on Nunda. This Odd Fellows street fair in the 1920s probably brought a lot of business to local merchants. (Nunda Historical Society.)

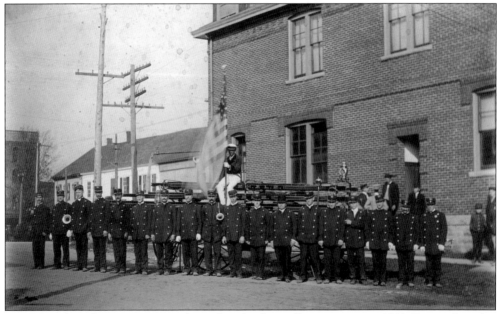

Nunda's earliest fire company was formed at the first village meeting in 1839. Except for a few months in 1872, Nunda was always protected by one or two fire companies whose festive balls and local parades became annual rituals. Here, Neptune Hook and Ladder No. 2 is seen on parade in front of the new fire hall built in 1900. (Nunda Historical Society.)

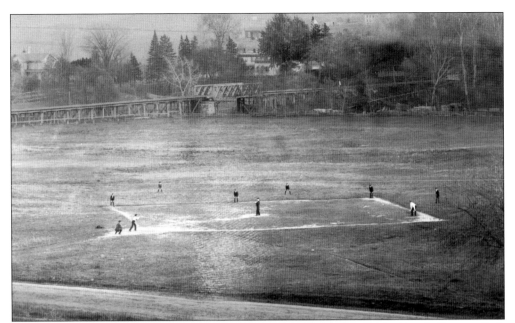

Nunda's first sports were wrestling matches and quoits. Horse racing at the Nunda Driving Park northeast of the village was also popular. Baseball became the town's passion when the Nunda Alerts formed in 1869. Games were first played in the square, but moved to this ball field located near present-day Kiwanis Park. The Swain's Branch train trestle is visible beyond the players. (Town of Nunda Historian's Office.)

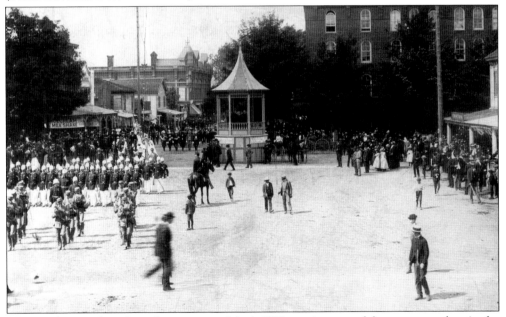

Area residents gather along the square on July 4, 1891, to view one of the many parades. At the center is the band pagoda erected the year before. Concerts were common on Saturday evenings during the summer with music provided by local bands. Folks would shop, listen to music, and enjoy an ice cream treat for 5¢. Local band concerts lasted well into the 20th century. (Nunda Historical Society.)

Church St

Nunda, N.Y.

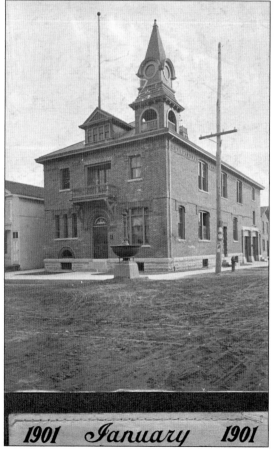

1901 January 1901

Municipal services became important. Electric streetlights, such as this one above the intersection of Church and East Streets, were first turned on in October 1893. The event was marked by a grand celebration complete with bands, the ringing of church bells, a bonfire, and fireworks. This c. 1905 image also highlights another service—water. The pipes on the far corner of the intersection led to one of the village's four reservoirs.

Nunda marked the coming of the 20th century with the completion of what the *Nunda News* called "one of the handsomest and best arranged village halls in Western New York." Completed in February 1900, the building included village offices, a fire engine house, a two cell "lock up," and hose and bell towers. The towers and the village office are now gone, but the building still serves as a fire hall and police station. (Nunda Historical Society)

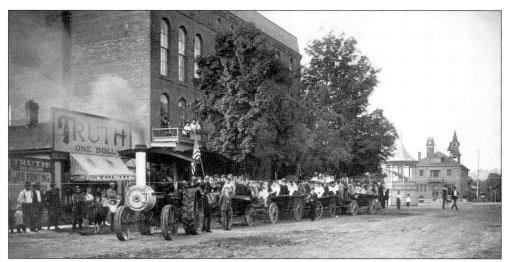

The Keshequa Masonic Lodge picnic of July 1904 was remembered for a long time. George Rathbun brought his new "traction engine" and lumber wagons to carry residents to nearby picnic grounds. Visible are the Livingston Block and the office of the *Truth*, a short-lived newspaper. What can't be seen is the lodge's goat that rode in a small wagon at the end of the train. (Ralph Watkins.)

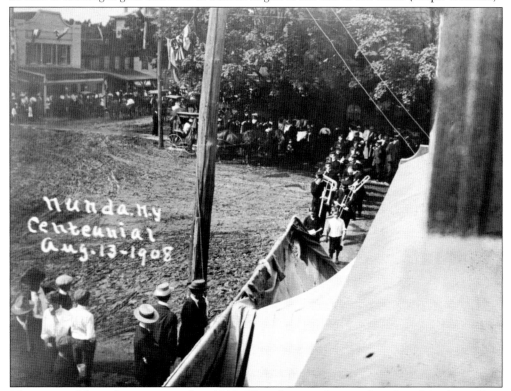

The town celebrated its centennial in 1908. This photograph was taken from Merchants Row during the grand fireman's parade held during the weeklong celebration. A heavy rainstorm that morning shredded street banners, damaged store awnings, and made the streets muddy for marchers. Former residents from around the country returned for "Old Home Week." The register of visitors is in the collection of the Nunda Historical Society.

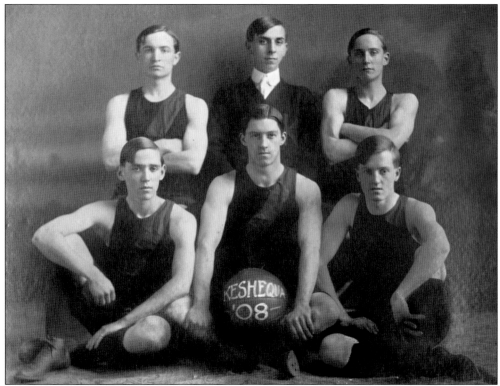

This photograph of a basketball team presents a centennial year mystery. The basketball is labeled "Keshequa '08." Keshequa is the name of the present-day school district formed from the merger of the Dalton and Nunda School Districts. That was in 1968. Why was there a Keshequa team six decades before the school was named? (Nunda Historical Society.)

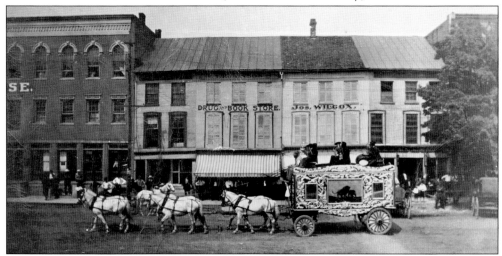

What appears to be a circus bandwagon travels down Nunda's State Street in the early 1900s. Circuses, street fairs, shows, and lectures were well attended in Nunda and Dalton. Although much of this entertainment came from traveling performers and speakers, the town had its share of homegrown talent. The noted hymn writer Philip Bliss, Obie Willard, Dick White, and Louis Willey were local musicians still remembered in Nunda. (Nunda Historical Society.)

One of Nunda's finest artists was Rose Shave, seated here in her studio on East Street around 1915. Trained at Ingham University in LeRoy, New York, she later studied in Paris. Returning to Nunda to paint and teach, Shave was considered among the nation's top watercolor artists. The Nunda Historical Society's Rose Shave Gallery holds many original works, including several of her paintings visible in this photograph. (Nunda Historical Society.)

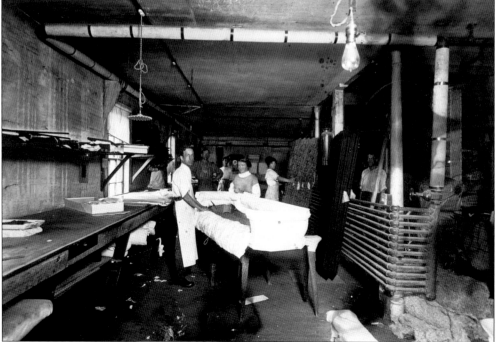

Nunda was known for three products in the early 1900s: knives, caskets, and cement mixers. Workers at the Nunda Casket Company, shown here around 1915, produced caskets. Originally a cabinet shop, the company began to make coffins in the 1860s. Four generations of the Willard family operated the business, which closed in 1980. The present post office marks the general location of this once important industry. (Wagor family.)

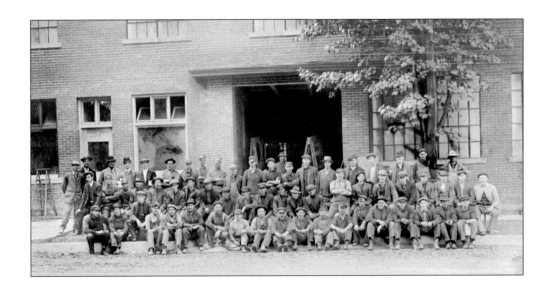

Chester and Charles Foote began to construct cement mixers in 1896. In 1903, the newly formed Foote Manufacturing Company sold the first mixer for street paving work. Expanding use of automobiles called for better roads, and in 1913 the company began a new brick factory along State Street to meet the growing demand. By the time the above photograph was taken in September 1914, the company had the largest workforce in the town. These workers and the generations that followed produced the Multi-Foote Paver and the Adnun (Nunda spelled backwards) Blacktop Paver. Nunda once boasted that it was the home of the largest exclusive manufacturer of road paving machines in America, if not the world. Some of the earlier mixers are shown in the photograph below. (Both Nunda Historical Society.)

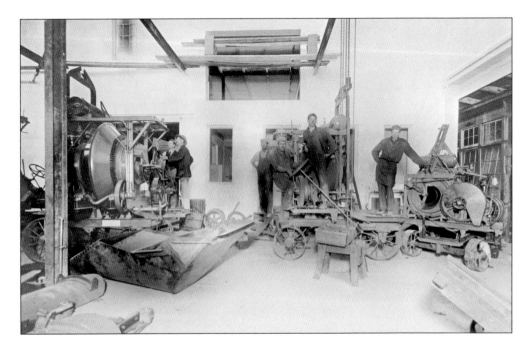

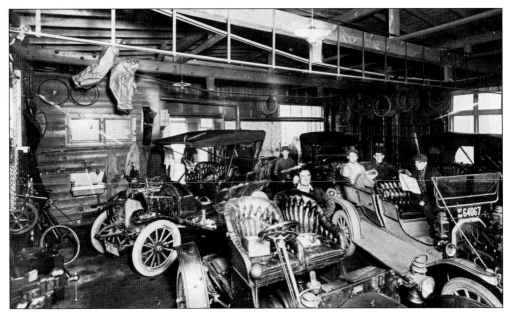

It was not long before dealerships and garages sprang up. Roy J. Cudebec opened the Nunda Garage on State Street in 1913 and briskly sold new Ford Touring Cars at $600 each. His mechanics provided what was advertised as "up-to-date garage service" for customers at the time of this 1914 photograph. The Nunda Garage once stood on the site of the present village parking lot. (Nunda Historical Society.)

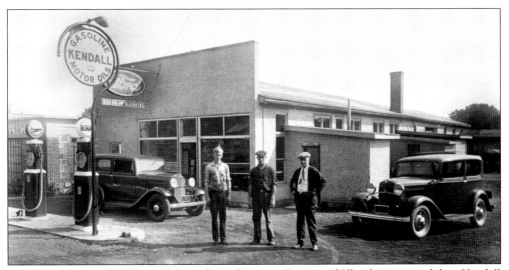

Several gasoline stations opened throughout the town. Brown and Kleinhenz opened their Kendall Gas Station on Portage Road in 1930 in a former knife works building. This business eventually became Tunningley Motors and later was an RV center run by Thomas Stamp. Stamp donated the building to the Nunda Historical Society in 1999. The building houses the Nunda Museum and Rose Shave Gallery. (Nunda Historical Society.)

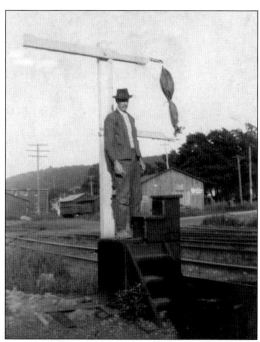

Although cars were growing in popularity, local railroads remained important. In addition to freight and passengers, local post offices depended on trains to move the mail. In this 1920s photograph, Wellington Parker stands next to the mailbag hanging from the mail post near the Dalton Station. The No. 1 and No. 2 "Fast Flyer" trains snagged the mail with their "bag catcher" as they passed through Dalton. (Archie Maker.)

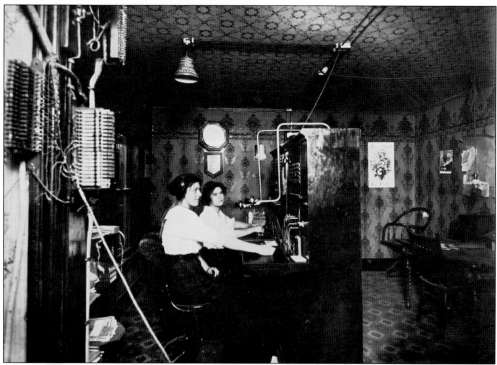

The first permanent telephone line in Nunda was installed in 1889, and by 1903 news items were routinely being called into the *Nunda News*. Soon, several local companies competed for customers, including the Livingston Rural Telephone Company of Dalton and the Business Men's Telephone Company of Nunda. Operators Anna Hinderland (left) and Frances Dolan handle calls at the telephone office on First Street before 1920. (Nunda Historical Society.)

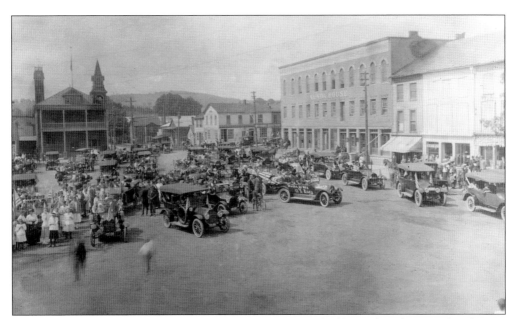

Local residents gather in the square in June 1917 to send off Nunda volunteers heading to Rochester at the beginning of World War I. Before the war was over, 109 area men would serve. Several, including 18-year-old Cecil Seager, never returned. Seager was killed by a shell along the Hindenburg Line less than two months before the armistice. The local American Legion post bears Seager's name. (Village of Nunda.)

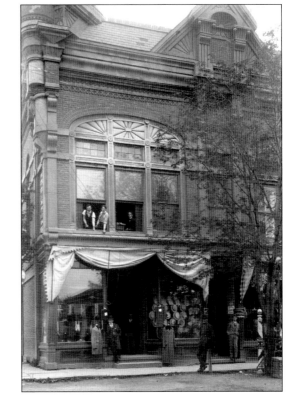

Businesses of every kind filled the storefronts in Nunda and Dalton. This shop in the Union Block offered gentlemen's clothing in the 1890s. The young men in the second-story windows work for Chauncey K. Sanders, who started the *Nunda News* in 1859. Sanders's son Walter B. "W.B." Sanders may be in the center window. W.B. ran the *Nunda News* until his death in 1971. (Town of Nunda Historian's Office.)

This image of a 1930s Decoration Day Parade was taken looking down Second Street from West Street. The marchers have just crossed the Pennsylvania Railroad tracks on their way to Oakwood Cemetery. Part of the train station is visible on the left. The building beyond the station is the Mary Jemison Inn. According to local stories, beer could be purchased at the inn during Prohibition—for medicinal purposes only, of course.

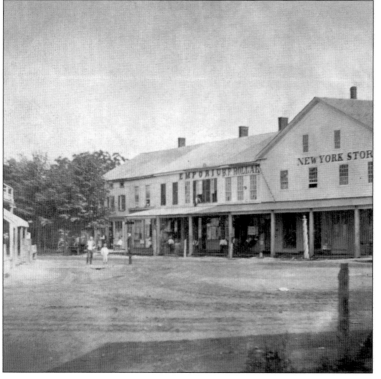

The most tragic fire in the town's history took place in December 1926. This stereoview from the 1870s shows the Emporium Block at the west end of East Street. The Thomas Stewart family was living in an upstairs apartment when the fire began. Firemen tried desperately to save the family but four-year old twins Kathlene and Illeen and two-year-old Patricia perished in the fire. (Karen Gibson Strang.)

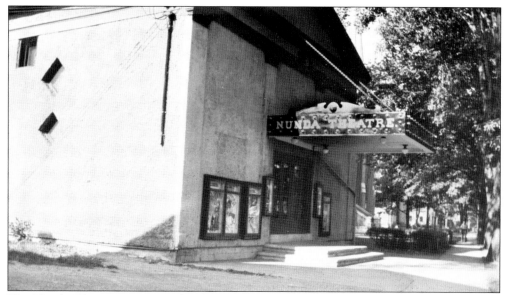

The Nunda Theatre was a popular place. Built in 1842 as the first Universalist Church, the structure was moved down East Street around 1874 when a new church was built. As the Academy of Music, it was the venue for concerts, plays, vaudeville shows, and, by 1920, for moving pictures. The Nunda Theatre operated until the early 1960s, when it was torn down for the library's parking lot. (Nunda Historical Society.)

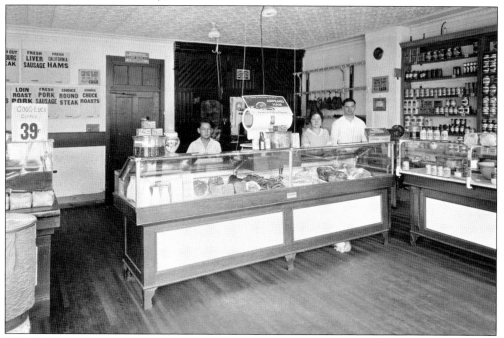

Salvatore "Sam" Bonadonna and his wife stand proudly behind the counter of their new grocery store in 1928. Like the Irish several generations earlier, Italian families initially faced some prejudice but soon became an accepted and important part of the community. Their grocery store operated on the East Street corner of the square for almost 50 years. The young man with them is delivery boy John Weaver. (Nunda Historical Society.)

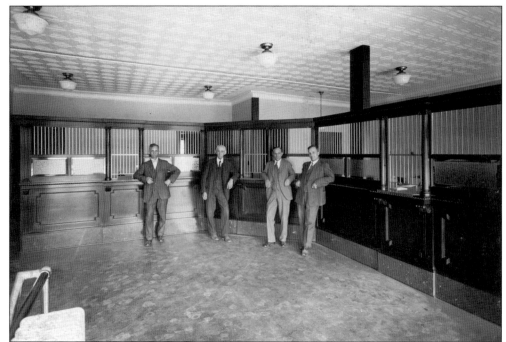

By the 1930s, there were three banks in Nunda: the Dalton Banking House, the Nunda Bank, and the Peter DePuy Banking House, shown here around 1930. Established in the 1890s, four generations of DePuys oversaw the bank. Third generation bankers Perry J. DePuy (far left) and brothers Glen R. (third from left) and Earl E. DePuy (far right) pose in their newly renovated bank. Longtime teller James Baker (second from left) poses with them. The DePuy bank survived the Great Depression, but the Nunda Bank run by Fred Olp did not. The picture below shows Olp's bank on the corner of State and First Streets shortly after it opened in 1917. The Nunda Bank thrived through the 1920s but failed in 1933. The Dalton Banking House closed its doors in 1939. (Above, DePuy family; below, Nunda Historical Society.)

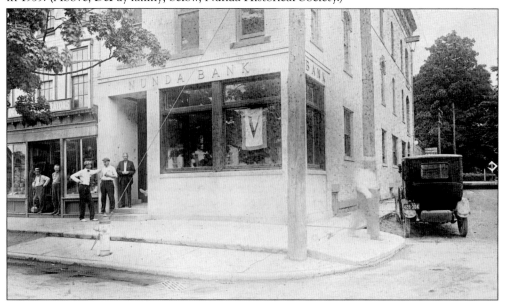

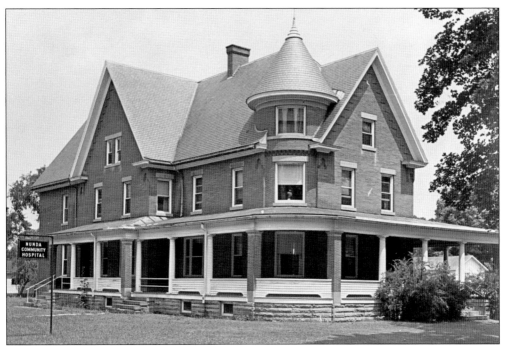

The Nunda Community Hospital opened on Massachusetts Street during the Depression. Originally the home of banker Isaac J. DePuy, it became the hospital in 1935. Nunda's hospital operated until 1960, when it became a nursing home. Eventually it was converted to an adult community home that closed in 2004. It is now the government center for the town and village of Nunda. (Nunda Historical Society.)

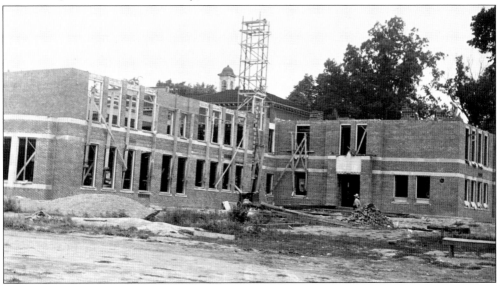

New Deal programs encouraged the construction of centralized schools. Two stories of the new Nunda Central School are visible in this photograph taken from Church Street in the summer of 1938. After the building was complete, the old high school, whose roof and cupola are visible, was torn down. Students entered the new building for the first time in April 1940. (Nunda Historical Society.)

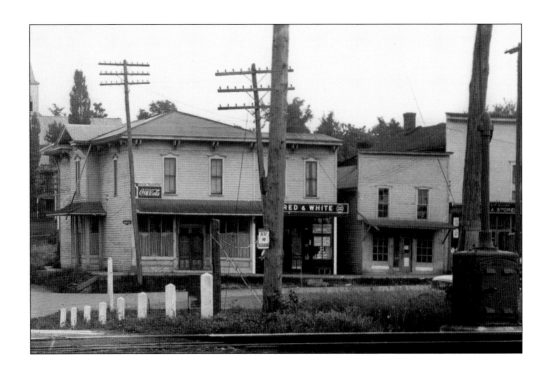

Fires had struck Dalton's business sections in 1917 and again in 1938. The fire of October 1943, however, was the worst of all. Driver Joseph Tallman was delivering fuel at the side door of Duane Wolf's Ice Cream Parlor, seen above on the left. Some of the fuel spilled and reached the water heater in the basement, causing an explosion and fire. Fern Buchinger, a parlor employee, was thrown from the building and badly burned. Water problems hampered firefighters until the railroad brought water, helping to save the community from more destruction. The photograph below shows the ruins of six buildings shortly after the fire. The building on the right was the old Dalton Banking House, then Haven's Barbershop, which survived with only a charred roof. (Above, Katherine Smith; below, Nunda Historical Society.)

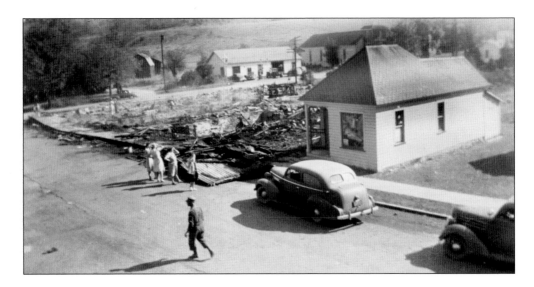

By the time Dalton suffered its great fire, Nunda and the rest of the country had been at war for nearly two years. The photographs on display at Nunda's Rainbow Coffee Shoppe in 1944 bear testimony to the many area men and women in the service at the time. This photograph and writing are attributed to Roy Gath. (Nunda Historical Society.)

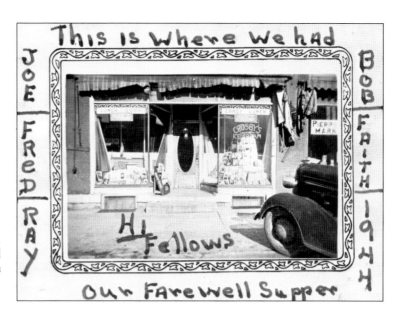

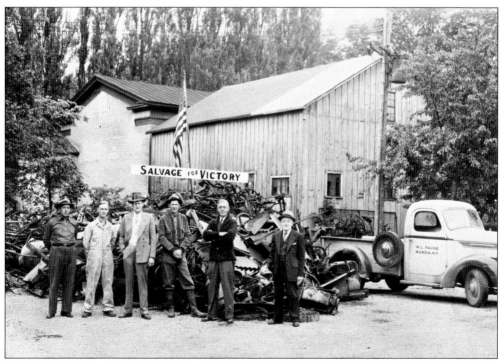

Doing their part to support the war effort, local residents proudly display piles of scrap metal during the "Salvage for Victory" campaign held in 1942. It is likely the cannons in front of the Carter Building (page 26) disappeared into the scrap pile. Welcome Paine (far right) was one of the leaders of the campaign. This photograph was taken behind Paine's shop on East Street. (Nunda Historical Society.)

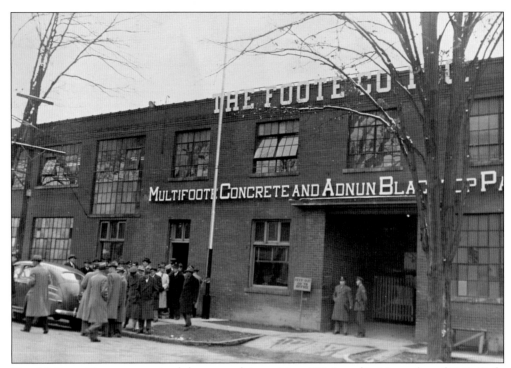

Nunda's Foote Company received the coveted Army-Navy "E" Award in November of 1943. Only about five percent of the many companies involved in war production earned the distinction. Dignitaries gather in front of the plant (above) in preparation for a grand parade to the school gymnasium (below) where officers of the army and navy awarded the special pennant and employee's pins. The company won the award two more times for its production of pavers used in both the European and Pacific theaters. The old gymnasium shown here was converted to the present school's auditorium in 1971. The stage where the ceremonies were held is still used. (Both Nunda Historical Society.)

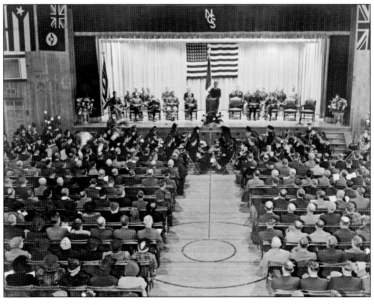

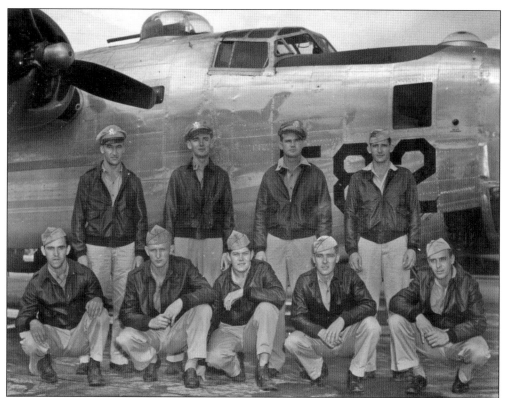

Tail gunner Clarence Stanley Kleinhenz (front row, center) poses with his bomber's crew sometime before the plane was lost over Austria in October 1944. He and Nunda resident Donald Duryea, who was killed in January 1945, were honored in 1947 when the new Veterans of Foreign Wars post was named for them. Seven area men were killed during World War II. (Duryea-Kleinhenz-Lathrop Veterans of Foreign Wars Post No. 8961.)

Like their ancestors before them, Nunda's soldiers returned from war to take their place once more in the community. Local veterans march on State Street past the American Legion's Carter Building in this photograph taken by Roy Gath during Veteran's Day ceremonies around 1950. The spectators to the right stand in front of a military honor roll that now hangs inside the building. (Nunda Historical Society.)

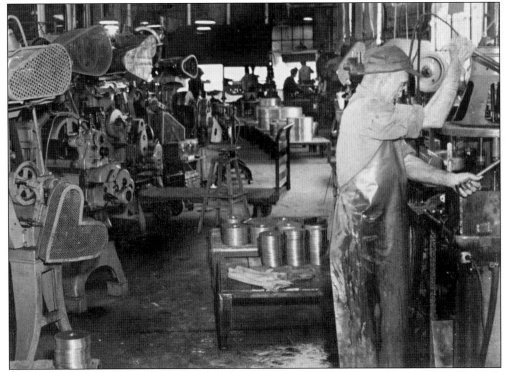

The postwar years seemed bright for Nunda. Some returning veterans found jobs at Piper & Paine, a rapidly growing business in the old silk mill building. Started as a machine shop in 1942 by Delos Paine and Harold Piper, the company produced forklifts and other machinery. In the 1950s, it produced the Trac-Paver, a small paving machine. Here Paul Willis works in the plant around 1950. (Nunda Historical Society.)

Alfred "Sod" Caryl drives Molly, his horse, and wagon, into the village square in the early 1950s. Born in the 1870s, Caryl lived through much of Nunda's golden age. A local farmer and drayman, his rig was a familiar sight in the village until his death in 1956. To many, Caryl and Molly were a reminder that the "good ol' days" were giving way to modern times. (Nunda Historical Society.)

Three

PORTAGE
1850s–1950s

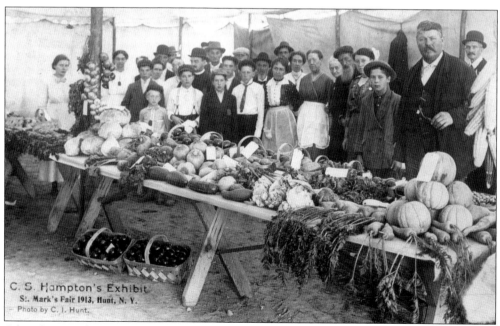

C. S. Hampton's Exhibit
St. Mark's Fair 1913, Hunt, N. Y.
Photo by C. J. Hunt.

After the completion of the Genesee Valley Canal and Portage Bridge in the 1850s, the town of Portage settled into the seasonal patterns of rural life. Spread across hills and hollows and farms and small communities, the people of Portage lived close to the land. Local residents pose with some of the bounty of that land in this 1913 photograph taken at a local fair. (Portage Town Historian.)

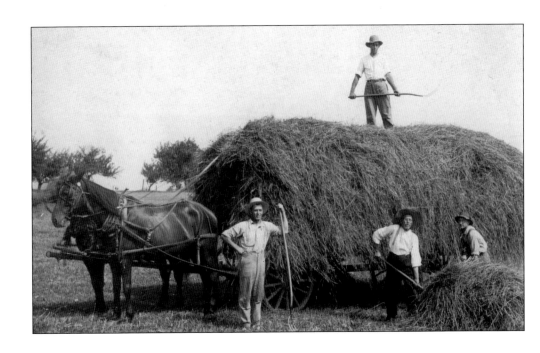

Agriculture was the mainstay of the town's economy, and the focus of daily life for most residents. The 1880 federal census for the town counted 297 families. Of these, two-thirds of the heads of houses listed their main occupation as farming. Blacksmiths, coopers, cheese-makers, and other businesses that served family farms were also listed. Farming was hard work, as the undated photograph of a hay wagon on a Portage farm (above) shows. Innovations such as the steam-powered thrasher (below) helped to increase the size of farms, but farming continued to be labor intensive. However, for many farmers it was a labor of love passed down through generations. (Above, Willett Family; below, Nunda Historical Society.)

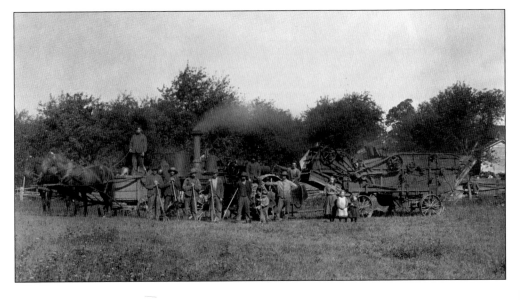

The Burroughs farm already had a prominent place in Portage history when the above photograph was taken in the summer of 1879. Once the site of Prosper Adams's pioneer tavern, it was later a busy stagecoach stop on Short Tract Road. It also served as a meeting place for local Mormons. When owner William Marks headed west in 1837, he sold the tavern and 60 acres to Phillip Burroughs. Below, Burroughs's son Andrew Jackson "Jack" Burroughs poses near the front porch of the Burroughs home around 1900. This house replaced the original tavern that burned in 1852. Jack lived nearly 80 years on the farm. His only daughter, Inez, married Frederick Willett, whose grandchildren still own the farm. Although altered over the years, the 1850s homestead still stands today at Willett's Corners. (Both Willett family.)

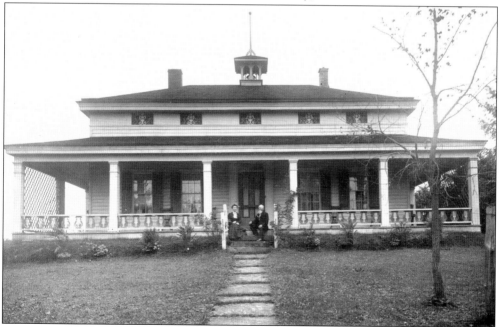

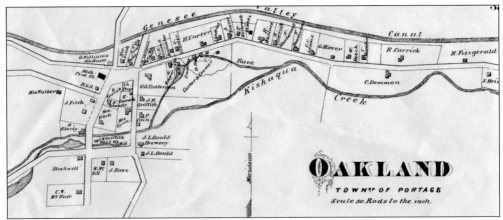

Communities were also important to area farms. Originally "Messengers Hollow," the hamlet of Oakland became a bustling port on the Genesee Valley Canal, as seen in this 1872 map. The canal's closing in 1878 impacted the community, but an 1881 description stated that Oakland included a "mill, carriage shop, a blacksmith shop, school house, a manufactury [*sic*] for plows and other agricultural implements." Note the spelling of Keshequa Creek.

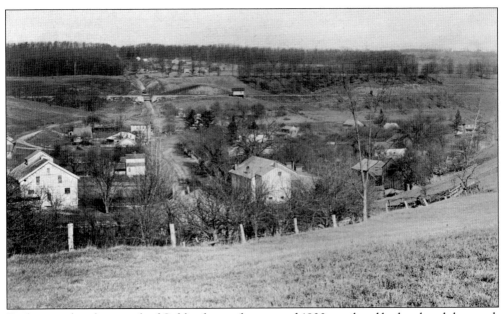

By the time this photograph of Oakland was taken around 1900, a railroad had replaced the canal. A keen eye can pick out the Pennsylvania Railroad tracks on the far hill, including the overpass on the road to Oak Hill and the small Oakland Station to the right of the bridge. This image was taken from the McNair property in the lower left of the above map, looking north.

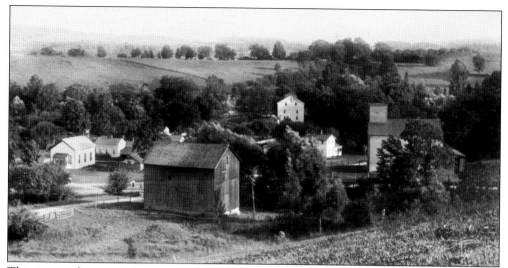

This image also comes from around 1900. It was taken from the opposite side of the valley, looking south. The large multistory building just right of center is Oakland Mills. To the right can be seen a church and to the far left is a one-story building that served as Portage Town Hall. All three buildings are gone.

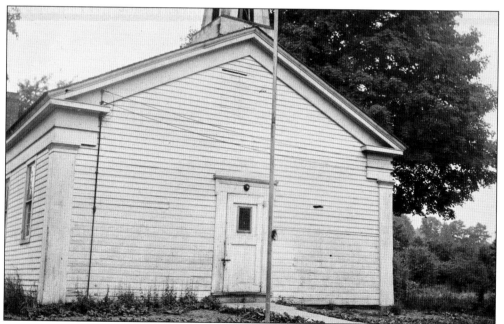

Oakland's schoolhouse still stands. This 1930s photograph shows the District No. 2 school about the time it became part of the Nunda Central School District. The building was converted into the Wesleyan Methodist Church in 1940. Alterations and additions have covered the original building, but it remains as one of the only public buildings from Oakland's early days. The school's bell is displayed at the Nunda Historical Society. (Nunda Historical Society.)

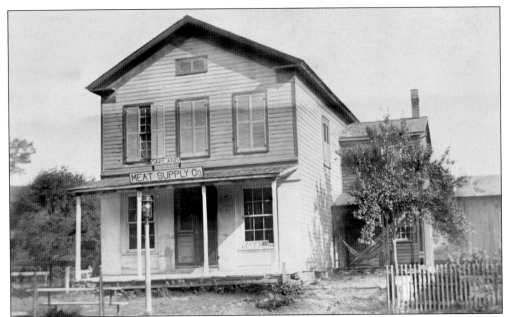

One of Oakland's many businesses was this store operated by H.C. Farnum. This building, labeled the "Oakland Meat Supply Co.," may have been the same grocery store that advertised free deliveries in the *Nunda News* in 1896. Farnum also was appointed postmaster of Oakland in 1894. The Oakland Post Office, once at the home of Col. George Williams (page 15), moved several times before being discontinued in June 1918.

There are two cobblestone houses in the area, the one on East Street in Nunda and this one on Oakland's Fitch Street. One account says Elias Fitch built it for his family, but another credits it to the Messenger family. A Mrs. Gould lived there around 1910 when this photograph was taken. The Nunda and Portage cobblestones are among the southernmost examples of this unique building style.

Hunts Hollow was the oldest and busiest community in Portage before the completion of the canal. A historical marker calls the area "Kishawa," one of several names given to the settlement in its early days. Hunts Hollow became official when the post office was established in 1829. The photograph above, probably by Jason Hewitt, was taken of the hollow in the early 1900s. Modern Route 70 still passes by the cemetery seen near the center, but it bypasses the community's central square. The undated image at right shows St. Mark's Episcopal Church in Hunts Hollow. The congregation formed in 1826 and the members, including the Hunt and Bennett families, erected the building in 1828. The last service was held at the church in May 1908. (Above, author's collection; right, Portage Town Historian.)

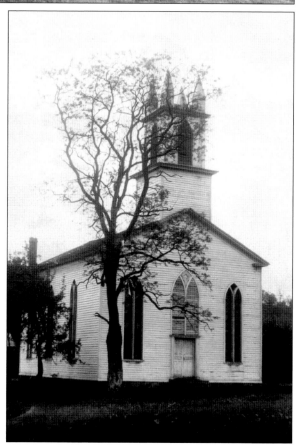

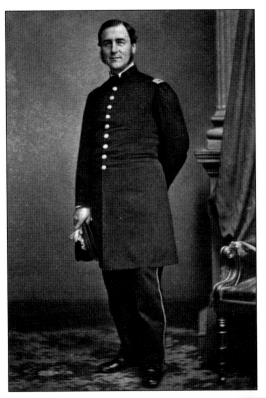

Edward Bissell Hunt (left) was the youngest son of Sanford and Fanny Rose Hunt. After a boyhood in Hunts Hollow, he graduated from West Point in 1843. He married Helen Maria Fiske in 1852 and brought her to Portage on their honeymoon. The image below shows Helen Hunt and their son Murray around 1854. Sadly, Murray died shortly after this daguerreotype was made. Capt. Edward Hunt became the country's first submarine casualty in October 1863 when he was killed testing a "torpedo projector" off Long Island. Helen moved west and eventually remarried. By the time of her death in 1885, Helen Hunt Jackson had become one of America's most influential female writers. Some say her visit to Hunts Hollow was the inspiration for her poem "October's Bright Blue Weather." (Both Helen Hunt Jackson Papers, Part 1 MS0020, Special Collections, Tutt Library, Colorado College, Colorado Springs, Colorado.)

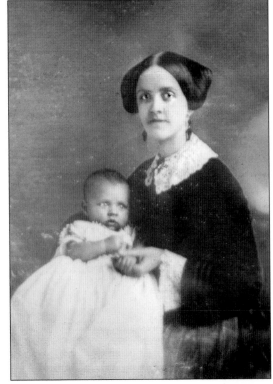

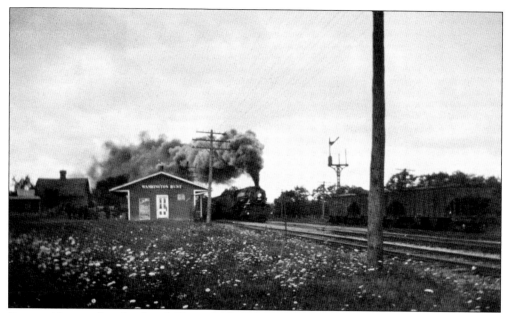

Bypassed by canal and railroad, Hunts Hollow slowly faded away. Perhaps it is more accurate to say "drifted away," for much of the community moved south closer to the railroad station, known at one time as the Washington Hunt station. Washington Hunt, brother of Edward Hunt, was governor of New York from 1850 to 1852. The post office moved from the hollow to the station by 1875 and was eventually called "Hunt."

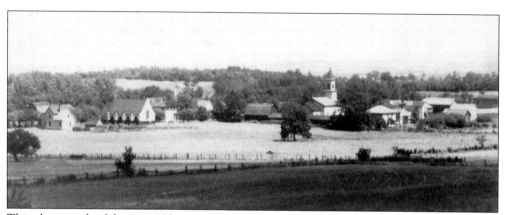

This photograph of the "new" Hunt was taken around 1915. By this time, the two congregations from Hunts Hollow had moved near the station. The new St. Mark's Episcopal Church (left center) was built in 1912. The Baptist church (right center) was literally moved from the hollow in 1884 at a cost of $2,500. St. Mark's Episcopal Church was torn down in 1967. The Baptist church burned in May 1955. (Portage Town Historian.)

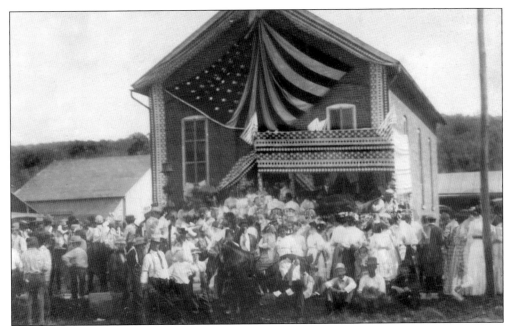

Hunt's Memorial Hall was dedicated in November 1880 in honor of the 152 Civil War soldiers from Portage. Townsfolk raised the $2,000 needed to build the brick building, which included three large marble tablets from Nunda's Squire Marble Works that bore the names of the men who died in the war. These cenotaphs still hang in the building. This photograph was taken on July 4, 1911. (Portage Town Historian.)

The *Nunda News* stated in the early 1880s that "Hunts is the business centre of the town (Portage) and bound to grow!" And indeed it did. By the early 20th century when this photograph was taken, the hamlet boasted five warehouses, several stores, two blacksmith shops, and more. The Memorial Hall's cannon is just visible behind the man on the left.

Hunt even had its own hotel. According to the *Portage Sesquicentennial History*, S. Parker first opened the hotel. It was later operated by Fancher Derrin and finally by the Shaylor family. The 1920 census lists widow Mary Shaylor as the hotel keeper. Her son George worked for the railroad. Later, the Gahagan family owned the building and a nearby gas station. (Portage Town Historian.)

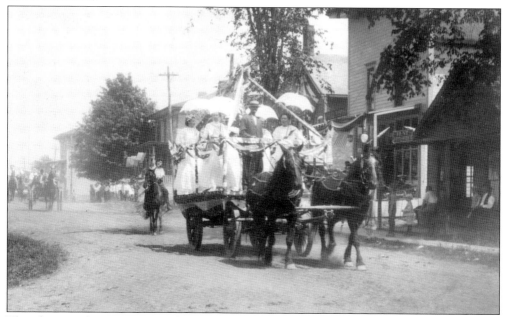

This photograph captures Hunt during the Fourth of July celebration in 1911. The day was filled with food and fun, and included a six-float parade, music by the Dalton band, and baseball games. The *Nunda News* proclaimed "it was a great undertaking for Hunt" and added that they "are to be heartily congratulated for the successful outcome." Unfortunately, the Hunt team lost to the Daltons, 11-9.

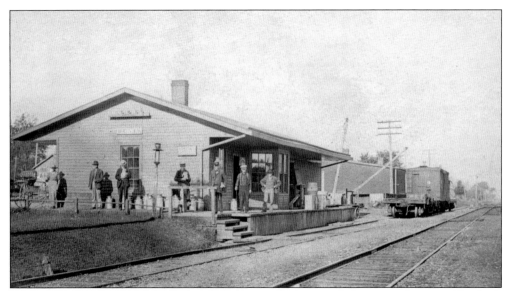

Local men pose at the station in this early-20th-century photograph. Late town historian Elizabeth Thompson wrote, "The Erie Railroad has served the community well. Much produce was shipped from the station. Potatoes by the carload, beans, grain, eggs, mill, and cream, as well as some livestock and poultry were sent. Many of the children went to Dalton by rail to attend school." (Town of Nunda Historian's Office.)

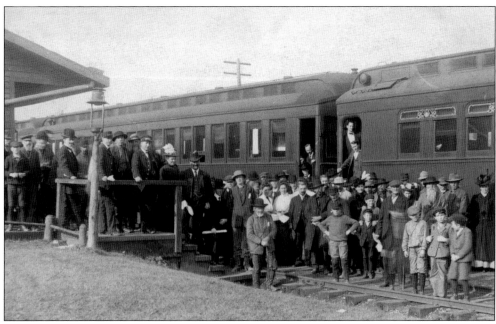

A group of passengers stands beside an Erie passenger train at Hunt's depot in this undated photograph. It is quite possible they are local residents going on a day's outing to the nearby picnic grounds at Portage Falls. A round trip excursion from Nunda's Pennsylvania station to Portage Bridge only cost 25¢ in 1900. (Willett family.)

Visits to Portage Bridge were popular since its construction in 1852. Travelers never tired of walking across the towering trestle. As a careful examination of this 1860s view shows, it was possible to walk through the bridge on narrow catwalks. The unknown photographer who took this photograph from the west end of the bridge was standing near the picnic grounds, which included a dance pavilion.

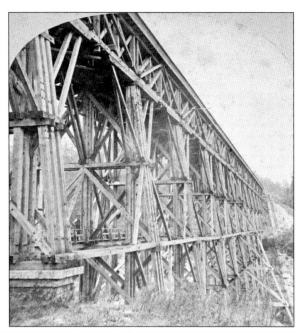

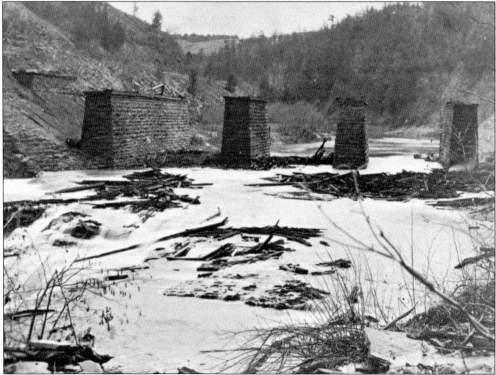

On May 6, 1875, Portage farmer Willis Merithew wrote in his farm journal "the Portage Bridge burned last night." The fire that started in the decking near the west end of the bridge quickly spread through the entire structure. By morning, the mighty wooden bridge was gone. When Warsaw photographer Lewis E. Walker took this image a few days after the fire, charred debris was still visible in the riverbed.

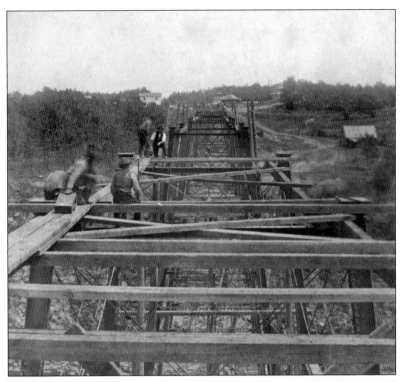

Work on a replacement bridge was soon under way. The above photograph shows workmen beginning to build the upper deck on the completed iron towers of the new bridge. In the distance, tourists watch the construction from the little community of Portage Bridge. The depot and tower are visible beyond the end of the new bridge, with the two hotels flanking the tracks. To the left is the Emerald House, which was popular with the bridge workers. To the right, almost hidden by trees, was the famous Cascade House. The new bridge (below) was completed by the end of July. L.E. Walker captured the first passenger train on the bridge in August 1875. (Above, Jane Schryver; below, author's collection.)

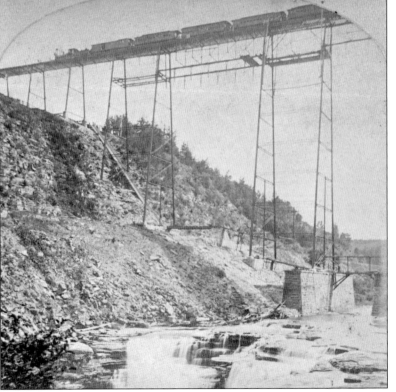

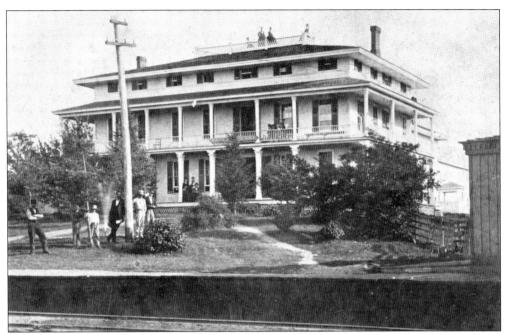

George Williams built the elegant Cascade House in 1852. An 1876 newspaper account described the hotel as "rich and aristocratic." In addition to well-furnished rooms and fine dining, the establishment boasted a two-story outhouse for guests. The well-stocked bar was also popular. In 1880, manager J.G. Barr temporarily lost his liquor license because he furnished liquor to fill a physician's prescription—on a Sunday.

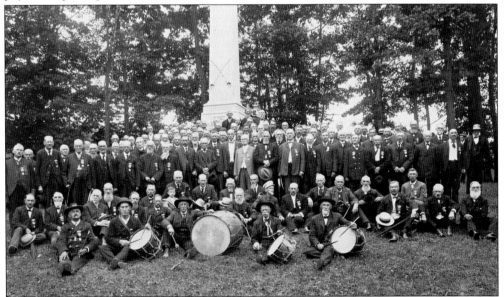

Civil War veterans pose near the 1st New York Dragoons monument. The Dragoons and the 136th New York Volunteer Infantry trained on the Parade Grounds, north of the bridge. Beginning in the 1870s, thousands attended the annual Soldiers' Picnic, held at Portage Bridge. The 1903 monument originally stood near the west end of the bridge. It was moved in 1919 to its present location in Letchworth State Park. (Nunda Historical Society.)

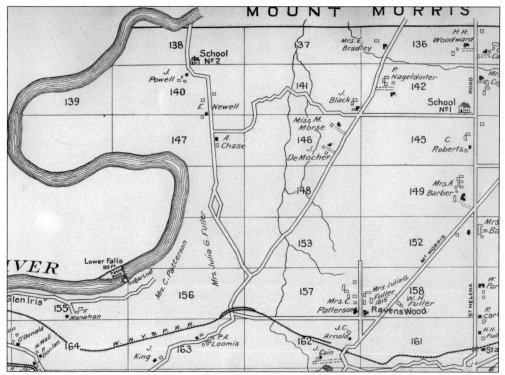

Oakhill, Big Bend, Deep Cut, Lewis Switch, and Mudville were familiar places a century ago. This portion of a 1902 town map of Portage (above) shows the location of several of them. Oakhill was the area surrounding school no. 1 on the map. It included the well-known Barber House on Short Tract Road (labeled Mount Morris Road). Ravenswood was George Williams's farm (page 15). The area surrounding school no. 2 was Big Bend. Several families lived at Big Bend, including that of Gertrude Bennett Herrington, seen below at her family's farm in 1916. Gertrude's Buff Rock chickens won a prize at the October 1913 Hunt Fair (page 57) and the next month she married Grant Harrington at her parent's Big Bend farm. Gertrude's family was among the last to leave as the land was acquired for Letchworth State Park. (Above, Bell Memorial Library; below, Cebelia Harrington Fusco.)

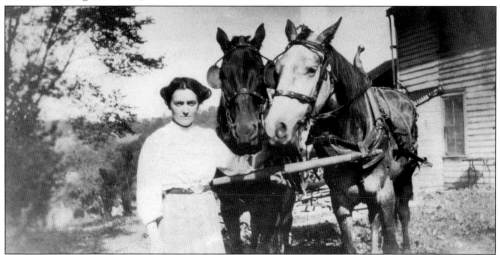

Although Irish workers originally dug the Deep Cut for the canal, the tracks of the Genesee Valley Canal Railroad ran through it by 1882. The Deep Cut station—which was really nothing more than a telegraph shack—was manned throughout the year by employees such as Martha Vail, seen here climbing the Deep Cut semaphore tower around 1918. Along with running the telegraph located in the station in the distance, Vail had to clean the lenses, trim wicks, and replenish the kerosene in the tower's signal lantern. Maintaining the tracks between Deep Cut and Portageville was not an easy job. The image below shows the railroad's steam shovel in 1907 at work near Deep Cut. By this time, the Western New York & Pennsylvania Railroad owned the line. (Right, Leicester Town Historian; below, Town of Nunda Historian's Office.)

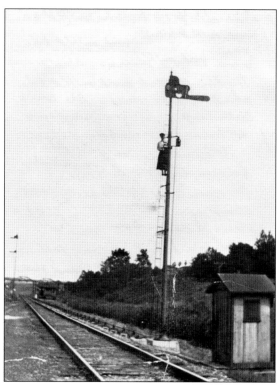

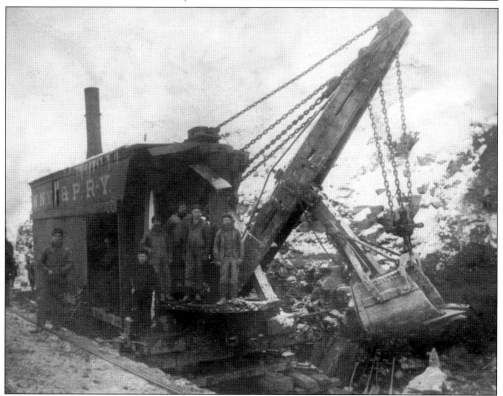

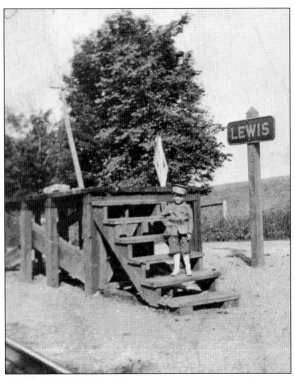

Just west of Deep Cut was a railroad siding called Lewis Switch. The Lewis brothers had come to Portage in 1879, attracted by the stands of pines and other trees along the Genesee River. By the time young Clifford Harris had this picture taken on the steps of the loading platform around 1920, most of the forest and the Lewises' sawmill were gone. (Leicester Town Historian.)

Members of the Otis Brown family pose outside their farmhouse in Mudville. Located along the Genesee River in southwestern Portage, the settlement once boasted a school, church, and 20 families. By the time this photograph was taken in the late 1800s, Mudville consisted of a half-dozen families. One of them was John Parry, the talented English cooper whose barrels and firkins are highly prized to this day. (Brown family.)

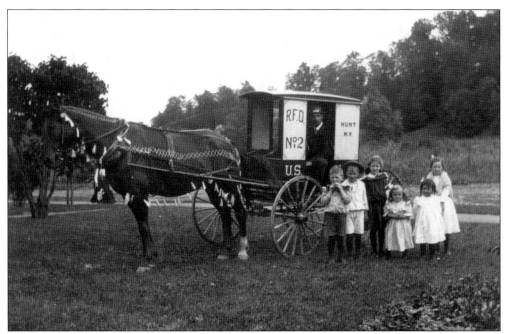

Rural Free Delivery connected the farms and communities of Portage and became an indispensable part of rural life after 1896. Mail carriers such as Jason Hewitt, shown here with admiring fans, were well known throughout the town. Hewitt carried mail from 1901 to 1927. He retired his horse and mail wagon for an automobile in 1916. Hewitt was also an avid photographer. (Town of Nunda Historian's Office.)

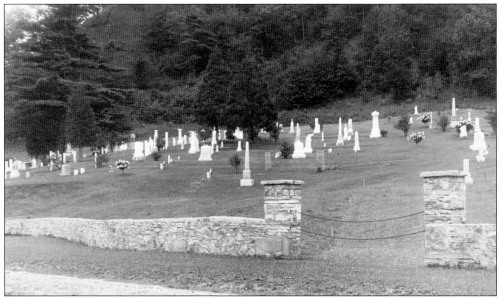

Jason Hewitt took this photograph of Hunts Hollow Cemetery around 1915. One of four cemeteries in the town, it is the resting place of generations of Portage residents. Sanford Hunt is buried here, as is Albion Grant Stockweather. A local businessman, Stockweather was elected to the New York Assembly in 1927. He knew everyone's name in his district along with, it is said, the name of every farmer's dog.

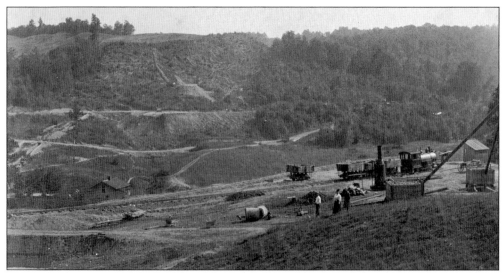

Portage had experienced the building of a canal, two railroads, and the great Portage Bridge. A fourth project began in 1906 when construction started on what locals called the "Erie cutoff," a 32-mile rail line from Hunt to Cuba, New York. Work was under way when E.H. Bennett took this photograph that shows the so-called "dinky" engine and dump carts used during its construction. (Town of Nunda Historian's Office.)

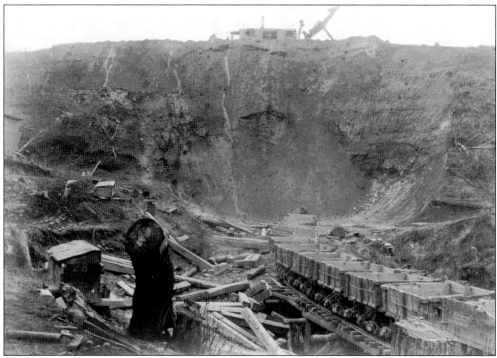

Ridges and gullies were formidable obstacles to the new railroad line. The original plans were to tunnel through the largest ridgelines, but the soil, known as "Caneadea slimy loam," made extensive tunneling impossible. Instead, workers excavated huge cuts through the ridges, such as Tunnel Cut No. 1, which is believed to be shown here. Great fills of earth bridged gullies above Mudville and other locations. (Town of Nunda Historian's Office.)

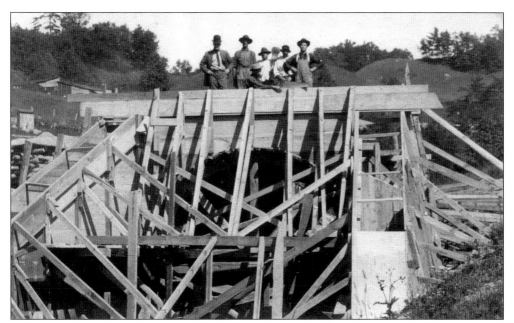

Most of the labor for this new line came from immigrants who lived in makeshift shanties on the construction site. More than 200 young men from Italy, Russia, Hungary, Serbia, and Poland appear on the 1910 federal census for Portage. Some laborers pose by one of the concrete arches used to carry local highways under the railroad. The Mudville Road "tunnel" is still in use today. (Town of Nunda Historian's Office)

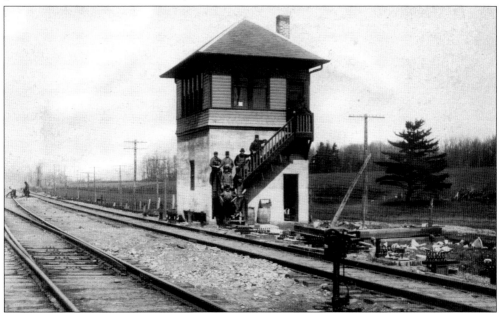

When work was completed in 1910 a new name, River Junction, appeared on local maps near Hunt where the new and old railroad lines met. The junction had several sidings, a few small buildings, and the tower shown here. Perhaps as many as 50 railroad employees worked at the junction maintaining the tracks and manning the all-important switches and signals. (Portage Town Historian.)

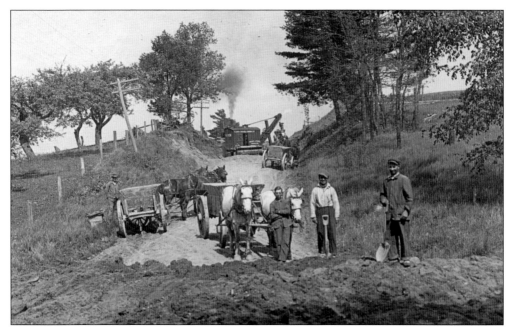

A smaller but significant project took place a few years later. Nunda contractor Frank Foote and his crew cut the new Portage Road from Nunda to Portageville in 1913. Frank was the brother of Chester and Charles Foote, owners of the Foote Manufacturing Company in Nunda. Although the last train ran on the Erie cutoff in 1977, Portage Road, now route 436, is still used. In the 1930s, the road was named "Ramona Trail" in honor of Helen Hunt Jackson. (Town of Nunda Historian's Office.)

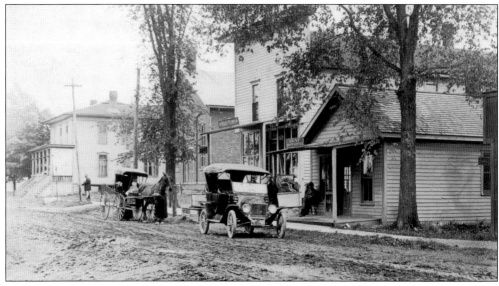

Change is in the air in this undated photograph of downtown Hunt. Some local men have gathered near the Hunt Post Office while both an automobile and a family's horse and buggy are parked nearby. Local construction projects, high crop prices, and improved roads encouraged many to put their family horses out to pasture. (Portage Town Historian.)

Although the pace of change accelerated throughout the 20th century, the family farm remained the center of the Portage economy for a generation or more. The Burroughs farm (page 59) was owned by Fred and Inez Burroughs Willett when this photograph was taken in the 1920s. By 1977, the farm and those of the Andrus, Nash, and two Thompson families earned the distinction of being "Century Farms." (Willett family.)

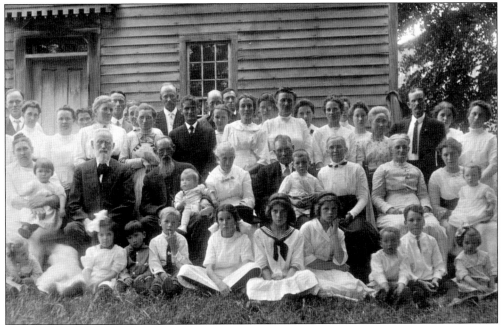

Family remained the cornerstone of Portage life throughout the new century. The William Thompson family poses in front of the family homestead in this 1914 picnic photograph. The Thompsons had come to town in the 1800s and descendants remain in the area today. Family reunion picnics are still held by the Thompsons and other Portage residents each year.

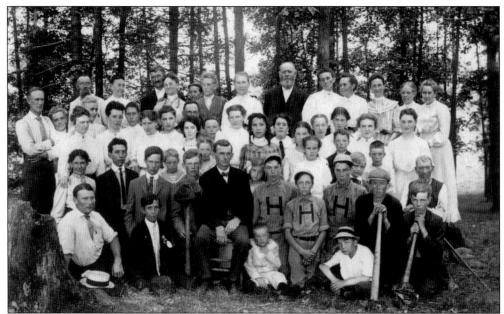

Although the photograph above was taken at the Hunt Baptist Church Sunday School picnic in August 1906, community gatherings and fairs were common through much of the 20th century. A baseball game was probably the high point of the day since several boys are wearing Hunt baseball uniforms. The Hunt Grange, organized in 1930, also sponsored dances and events. Election day dinners were another long-standing tradition. (Willett family.)

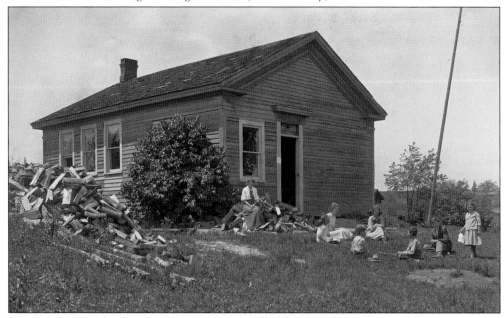

Portage's district schools were an important part of life for more than a century. This image, taken from a glass plate negative, captures the teacher and students relaxing in front of District No. 4 school on Baker Road north of the Allegany County line. In early days, families supplied cords of wood to the schools. This may still have been the practice when this photograph was taken around 1910. (Jane Schryver.)

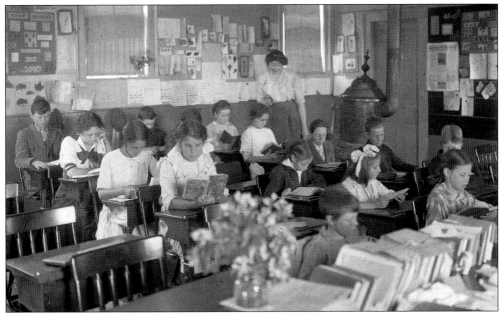

The teacher monitors her students' reading at District No. 10 at the corner of Valley View and Short Tract Roads. The school included students from Mudville and Hunts Hollow after those schools closed. A vase of flowers, perhaps brought by an adoring student, decorates her desk. The classroom walls reflect the varied levels of the students. Centralization ended this important aspect of rural life. (Jane Schryver.)

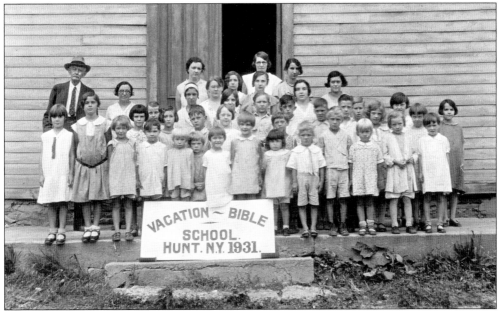

Churches in Oakland and Hunt provided for both the spiritual and social needs of their congregation and communities. Christmas and Easter celebrations were part of the rural calendar, as were the vacation bible schools sponsored each summer by local churches. Jason Hewitt photographed this group in front of Hunt Baptist Church in 1931. Although these children probably didn't know it, their town and nation were facing dark economic times.

Although self-sufficient in many ways, local farms and communities struggled during the Great Depression. President Roosevelt's New Deal reached Portage in June 1933 when the first of four Civilian Conservation Corps (CCC) camps in Letchworth State Park opened. Camp 23, shown here in 1934, was built on the flats by the river near present Cabin Area E on the east side of the park.

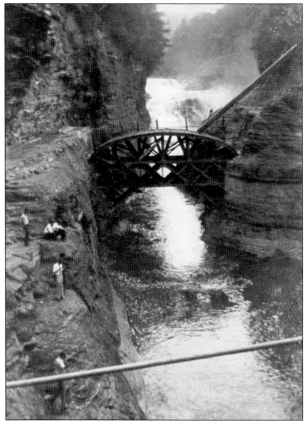

The CCC program is best remembered for its conservation and construction work. The workers did many of the roads, bridges, shelters, and stonework in the park. One of their most famous accomplishments was the Lower Falls footbridge, shown here under construction in a photograph taken by Roy Gath. The camps served another important purpose: they provided an economic stimulus to Portage and other neighboring towns. (Nunda Historical Society.)

The CCC program provided jobs and taught work skills to unemployed young men. Many local men joined the program and earned $30 a month, most of which was sent home to their families. Older area men served as foremen. Although Camp 23 only operated for 30 months, it later served as a Work's Project Administration camp. A chimney from the camp is still standing on the site. (Nunda Historical Society.)

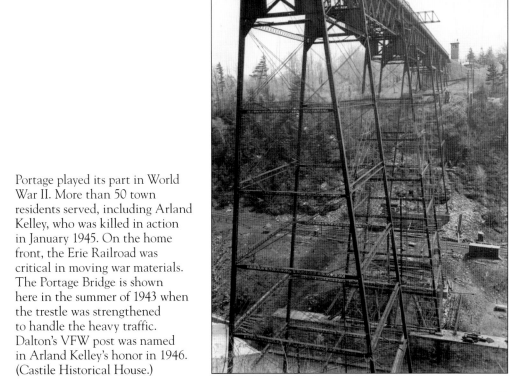

Portage played its part in World War II. More than 50 town residents served, including Arland Kelley, who was killed in action in January 1945. On the home front, the Erie Railroad was critical in moving war materials. The Portage Bridge is shown here in the summer of 1943 when the trestle was strengthened to handle the heavy traffic. Dalton's VFW post was named in Arland Kelley's honor in 1946. (Castile Historical House.)

Returning soldiers probably bought gas at Clarence Redmond's service station on Main Street in Hunt. Redmond ran the station from 1937 until his death in 1954. He also worked for the railroad at one time and served as the guard at the crossing outside Hunt. Local residents remember buying candy at his gas station and at Shore's store down the street. (Portage Town Historian.)

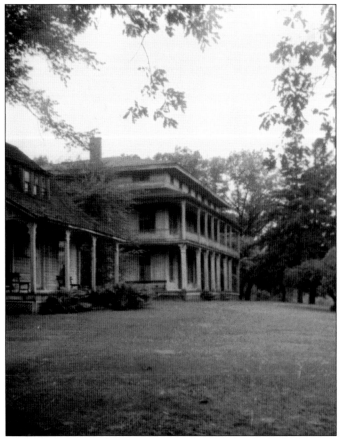

Portage faced many postwar changes. The heyday of tourists and excursion trains was gone, and the Hunt and Portage Bridge stations closed in 1952. The once elegant Cascade House, seen here in the 1940s, was just a shadow of its former self, with few visitors stopping at the hotel or nearby cottage. Although the Cascade House burned in 1965, the story of Portage continued into modern times. (Seymour family.)

Four

GENESEE FALLS

1846–1950s

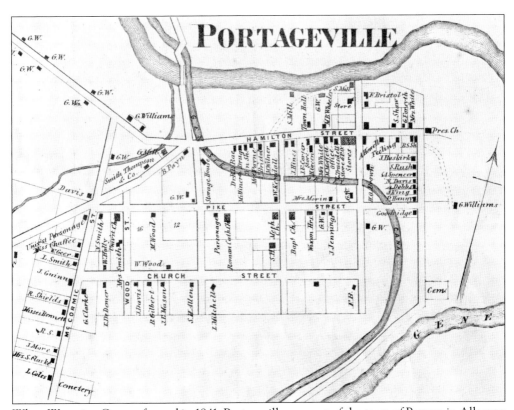

When Wyoming County formed in 1841, Portageville was part of the town of Portage in Allegany County. It wasn't until Portage and Nunda were annexed to Livingston County in 1846 that Portage's lands west of the river were combined with parts of the town of Pike to form the town of Genesee Falls in Wyoming County. Portageville, shown in this 1866 map, was the center of the new township.

Genesee Falls had about 1,200 people in the 1850s. Nearly one of every eight residents had been born in Ireland; workers were drawn to the area due to the work available on the canal and railroad. Many of these families stayed in Portageville after the construction was finished. Martin E. Brogan (center) poses on the front porch of his Hotel Edmore in 1913. His parents, Peter and Rose Brogan, had come to America in 1860.

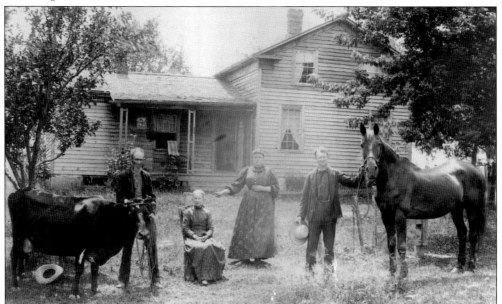

Many Genesee Falls residents made their living from the land. There were 96 farms in the town in 1875 that produced a variety of agricultural products. Lillian and Elbert Bull (right) pose in front of their farmhouse with their parents, Wyman and Lydia Bull, a cow, and their horse, Mag, in this late-19th-century photograph. Bull also ran the Portageville cheese factory for several years. (Carma Bull Stone.)

One of the largest landowners in Genesee Falls was William Pryor Letchworth. A successful industrialist from Buffalo, New York, Letchworth began to purchase acreage in 1859. His Glen Iris Estate grew to 1,000 acres along the Genesee River and included the Upper, Middle, and Lower Falls. Although it was Letchworth's private estate, his gates were always open to visitors. Thousands came each year, including the two men enjoying the Glen Iris pond and fountain in the image at right, which was taken by Henry Besancon of Pike, New York, in the late 1860s. Behind them is Letchworth's home, the present Glen Iris Inn. The 1880s photograph below shows tourists at the grave of Mary Jemison, the famous "White Woman of the Genesee." Beyond them is the Seneca Council House from Caneadea that Letchworth had restored and dedicated in 1872. (Right, author's collection; below, Karen Gibson Strang.)

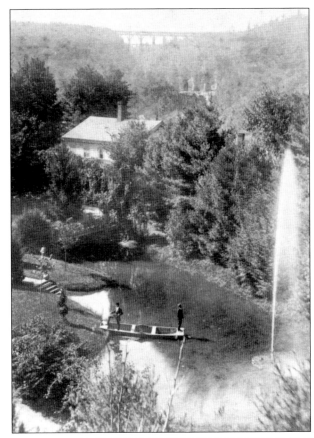

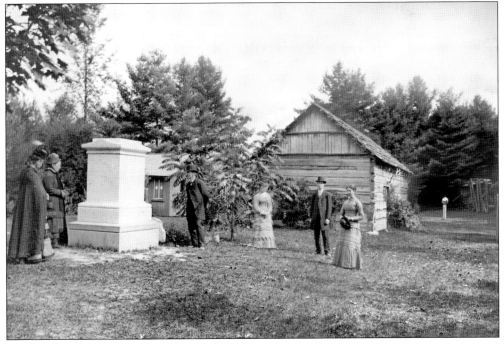

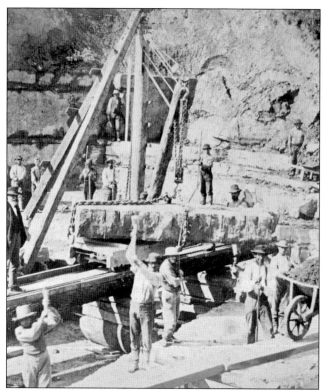

The lands of Genesee Falls produced more than farm products and scenic views. An 1897 trade magazine article stated, "Good blue sandstone is a rare product. None are better than the Portage bluestone quarried by the Genesee Valley Bluestone Company of Portageville NY." First opened during canal construction, the two quarries south of Portageville continued to produce the quality building stone for more than a century. Many of the early quarrymen were Irish, followed by German and Italian stonecutters. These two images are from 1870s stereoviews. The photograph at left shows the cutting of a large block in the quarry. Below, workmen ready the bluestone for shipping on the Genesee Valley Canal, visible to the far right.

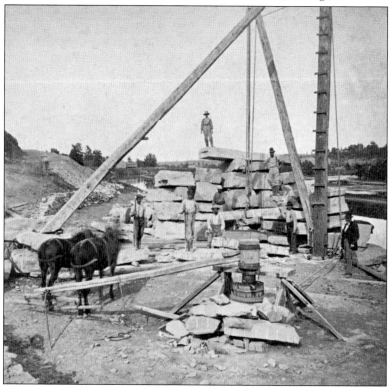

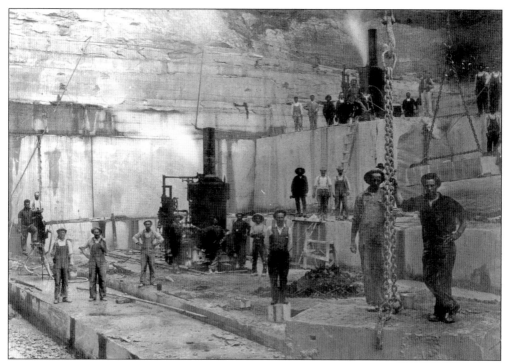

Workers quarry bluestone using steam machinery in this late-19th-century photograph. The American Bluestone Company (also known as Ambluco) was organized in 1894. The company added electric power to the quarry in 1927 that allowed for new channeling, cutting, and hoisting machinery. Several generations of Genesee Falls families worked at the quarries. Many lived in boarding or tenant houses near the site. (Seymour family.)

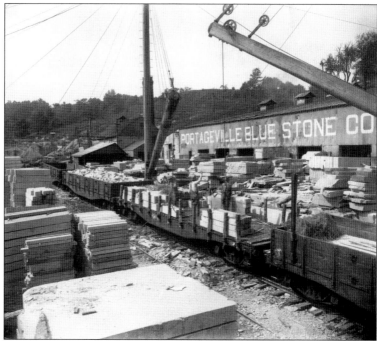

The closing of the Genesee Valley Canal in 1878 posed a critical problem for the bluestone companies. The quarries were saved when the Genesee Valley Canal Railroad was built along the old canal towpath. This railroad, later the Western New York and Pennsylvania Railroad (known as the "Pennsy"), allowed Portageville bluestone to be shipped all over the northeast. (Seymour family.)

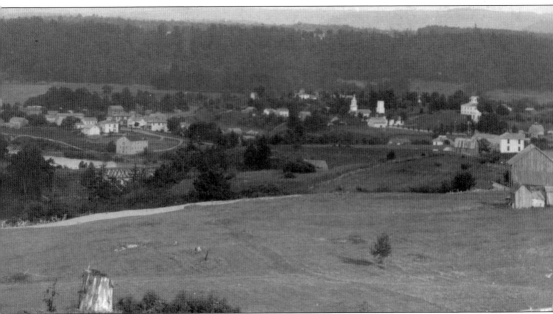

Although farms, bluestone quarries, and the Glen Iris Estate were important parts of the town, Portageville was the heart of Genesee Falls. This undated photograph, perhaps taken around 1900, provides a panoramic view of Portageville from the west. The community had become an incorporated village in 1866 with local businessman Henry O. Brown as its first president. Although the residents voted to revoke the village charter in 1874 and its population slowly dwindled, Portageville continued to flourish well into the 20th century. A 1910 description of Portageville listed four churches, two hardware stores, one jewelry store, three groceries, two general stores, three hotels, a meat market, one barbershop, an undertaking business, and a furniture establishment. There was also a school, post office, billiard parlor, livery stable and stage, two doctors, and an ink factory in Portageville. (Castile Historical House.)

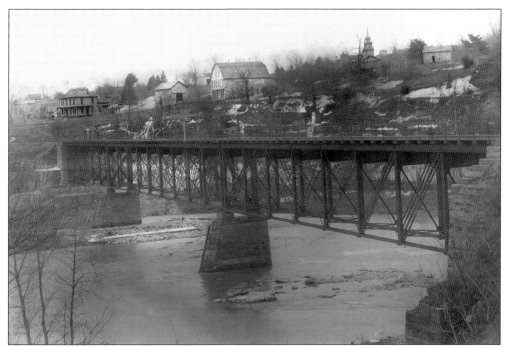

The key to Portageville's success was its location on the river, canal, and later, the railroad. The Pennsy followed the route of the abandoned Genesee Valley Canal through Genesee Falls. The bridge that carried the railroad across the river and into Portageville, shown above around 1900, used some of the original stone piers from the old canal aqueduct. The c. 1890 photograph below looks across the bridge into Portageville. The people on the far end of the bridge may have ignored the sign that warns "No Thoroughfare, Trespassing Forbidden." Several Portageville landmarks are visible beyond the bridge. The Church of the Assumption is visible to the left, and the school stands to the far left. The small building not far from the end of bridge was the blacksmith shop of Hiram Trowbridge (page 94). (Both Genesee Falls Town Historian.)

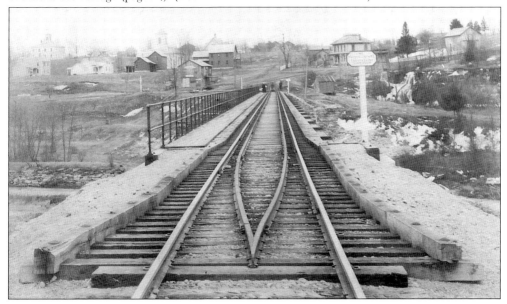

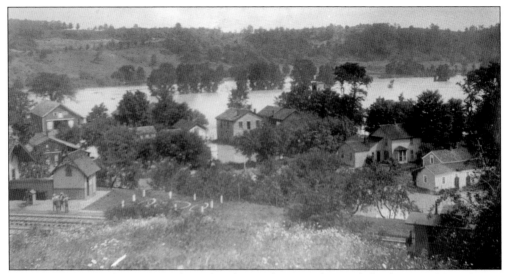

After crossing Hamilton Street, the railroad turned eastward toward the depot on Main Street. The tracks and part of the depot are visible in the lower left of this 1902 photograph taken from the corner of Main and Church Streets. Beyond the tracks the Genesee's floodwaters inundate the houses on River Road. From the depot the tracks curved to the south and followed the river toward Fillmore. (Seymour/Cottrell family.)

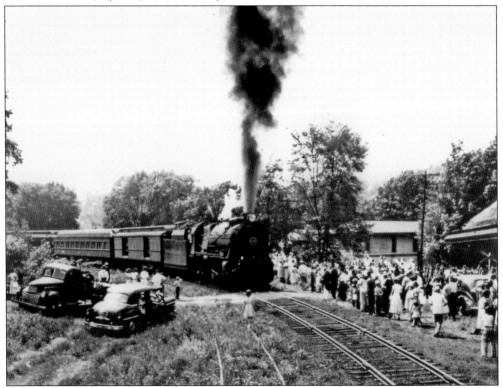

Local folks gather along the tracks near the depot to welcome an excursion train in this image dated 1951. Trains continued to run through Portageville until 1963. When the depot was torn down, the lumber was used to build a nearby house. (Genesee Falls Town Historian.)

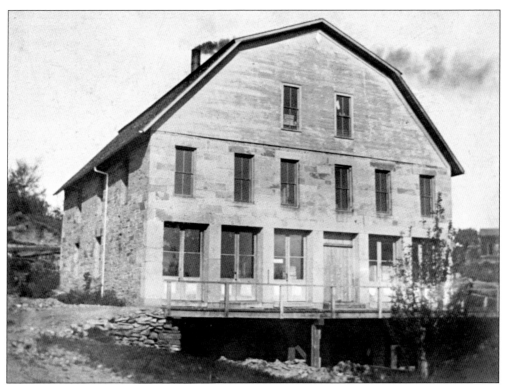

The Clark Ink Company was an important part of the local economy. An October 1899 *Nunda News* article reported the company "is in flourishing condition at the present time . . . This concern occupies three floors and the basement of the old stone mill . . . the basement contains the large ink vats, the first floor the office and shipping rooms, the second floor the packing and filling rooms, and on the third floor is the chemical room. All grades and colors of inks are manufactured and their bluing is in great demand." The article goes on to report that 15 were normally employed at the factory, though the number doubled in the "busy season." Salesmen "keep the company well supplied with orders from all parts of the United States." The photograph was taken before 1890. The business went bankrupt in 1903. (Above, Genesee Falls Town Historian; below, author's collection.)

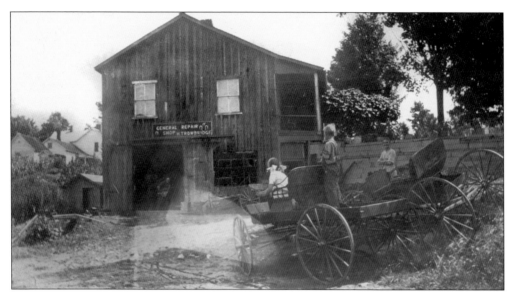

A number of small businesses operated throughout the town. The sign above the doorway proclaims this to be the "General Repair Shop" of Hiram Trowbridge near the railroad bridge on Hamilton Street. The blacksmith, probably Hiram himself, happily shoes a horse in the doorway while a woman and two children look on. They may be his wife, Cora, and their two youngest children, Bertha and Prosper. (Karen Gibson Strang.)

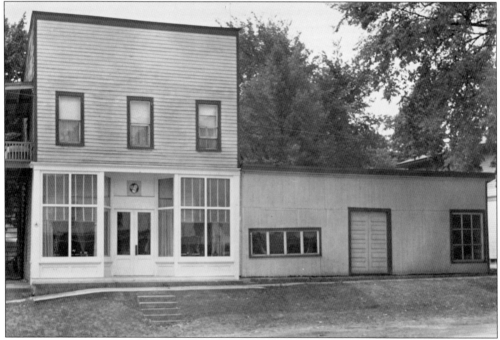

One of the hardware stores mentioned in the 1910 description belonged to Martin Brogan. Brogan built the store on the corner across Hamilton Street from his Edmore Hotel in 1908. Shown here in 1950, the building originally included a public hall on the second floor. Brogan's building later held an ice cream parlor, but most residents know it as Frank Oliver's bar and restaurant. (Genesee Falls Town Historian.)

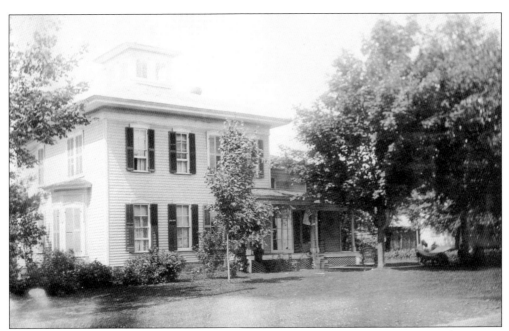

Local prosperity was reflected in many of Portageville's houses. This Hamilton Street house was built around 1865 with a bluestone foundation. One source states George Williams, who owned the mill nearby, built the stately house. Later it was the home of prominent businessman Augustus Beardsley. In more recent times the house belonged to the Davis family. Note the family relaxing under the trees on the right. (Genesee Falls Town Historian.)

Another noted resident was Dr. Robert Rae. Born in Scotland, Rae came to America as a boy in 1848. He served as a surgeon with the 1st New York Dragoons during the Civil War and returned to Portageville to practice medicine. By his death in 1911 he had provided medical care to area residents for more than 50 years. Rae had also served as Portageville's last president. (Seymour/Cottrell family.)

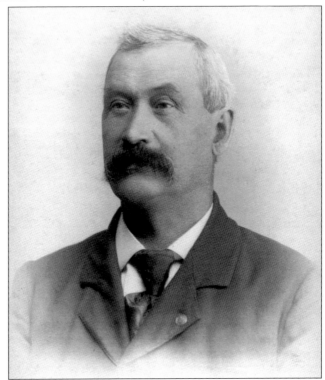

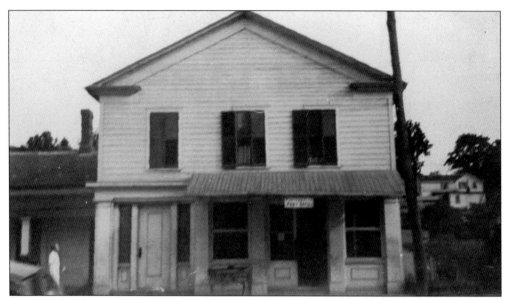

The history of the Portageville Post Office began when Elisha Moses was appointed postmaster on October 3, 1825. It was then called "Portage" and served the western portion of that town. The name changed to Portageville three years later. Although Genesee Falls was formed in 1846, the post office wasn't relocated to Wyoming County until 1853. Grace Brown was postmaster when this 1926 photograph was taken. (Karen Gibson Strang.)

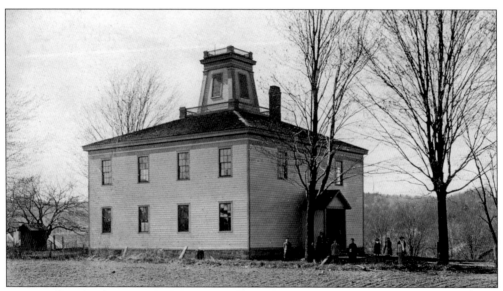

Portageville School No. 3 served Genesee Falls for many years. The *Nunda News* announced in July 1962 that the school's 50 students and two teachers, Esther Podlesney and Ruby Goodrich, would be transferred to Nunda Central School. The fire company bought the school and used it for dinners for several years before it was torn down. This real photo postcard is postmarked 1938. (Jane Schryver.)

Several church steeples can be seen in the photograph on page 90, representing a long and significant religious presence in Portageville. Among the earliest were Presbyterians, who organized in 1827. This building, at the corner of Hamilton Street and River Road, was their second church. It had been sold to Harvey Halstead by the time of this c. 1890 photograph. The old church is now gone. (Genesee Falls Town Historian.)

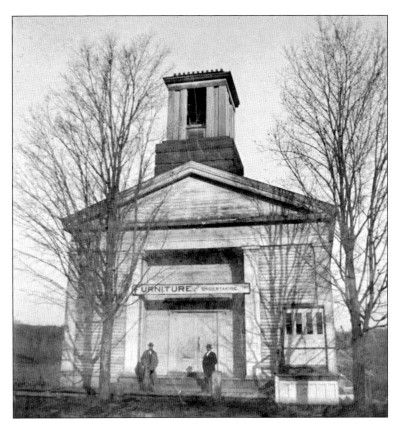

Other churches included those of the Baptists, Methodists, Universalists, and Roman Catholics. Here the parishioners of the Church of the Assumption await the beginning of mass during the church's centennial celebration in 1949. The Irish families who built the church during canal days were joined by Italian families in the early 20th century. Their descendants were still members when the church closed in 2008. (Mary Colombo.)

By World War I, Portageville had become a hotel town. There were three significant hotels in operation at that time, the best-known being the Genesee Falls Hotel, shown above in the 1950s when the Williams family owned it. After the original building burned in 1852, owner Joseph Ingham rebuilt it on the corner but lost that building in an 1870 fire. A three-story brick building rose from the ashes and still stands today. Boxer John L. Sullivan fought there and local lore says the Trapp Family Singers and Gov. Franklin Roosevelt were once the hotel's guests. The Joyce family owned the hotel when the photograph below was taken in 1933. Local patrons celebrated the end of Prohibition in grand style at this bar, probably toasting the former hotel guest who had become president of the United States. (Both Genesee Falls Historian.)

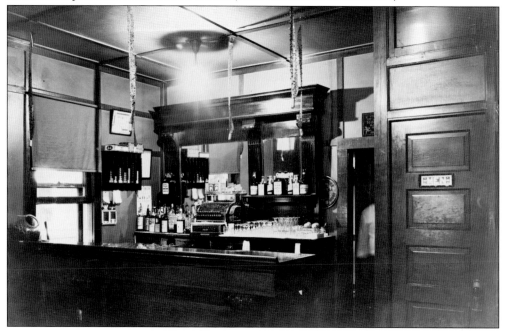

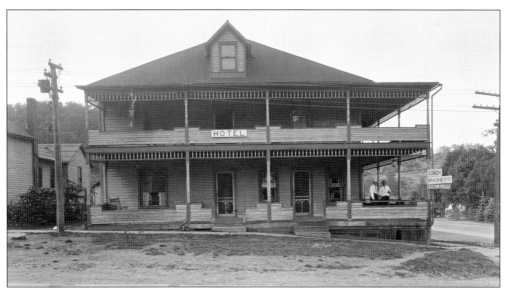

Martin Brogan built the Edmore House in the early years of the 20th century. He sold it to Peter Strum in 1908, but resumed ownership in 1910 upon Strum's sudden death. Brogan died in 1919. Later, Italian immigrants Eno and Jennie Colombo purchased the building for their home. After Prohibition, the Colombos served dinners and had overnight guests. The photograph was taken in 1934. (Genesee Falls Town Historian.)

A group poses in front of the Bristol Hotel in this undated photograph. Fred Bristol ran the hotel until his death in 1905, after which F.E. Tobias took over. The *Nunda News* reported in 1905 that Tobias was "conducting a first class house and enjoying a good run of patronage." Eight years later, the *Nunda News* reported that the hotel was to be closed and turned into a warehouse. (Bill Totsline.)

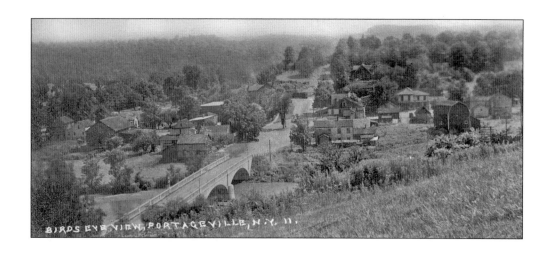

Tourists often arrived at the Portageville depot, especially around the time the annual Soldiers' Picnic was held. After checking into one of the local hotels, they hired a local driver to take them across the river bridge and up Erie Hill to Portage Station. For many years Clark Garrison carried passengers in his horse-drawn stage. Later, Dan O'Boyle used a Model A Ford. The above c. 1920 postcard shows the concrete bridge that replaced the earlier iron bridge in 1916. The photograph below is believed to document the bridge's dedication ceremony. In it, a group of dignitaries marches down Main Street toward the new bridge. The new road out of Portageville, still known as the "dugway," can be seen in the distance. The electric lights on the bridge were an impressive sight at night. (Both Karen Gibson Strang.)

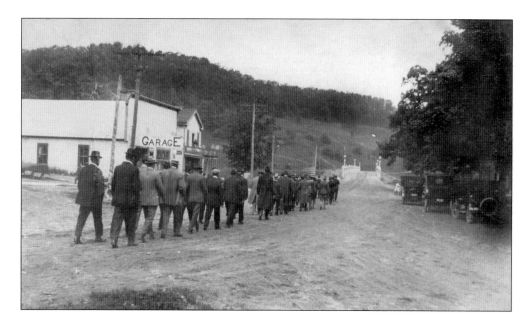

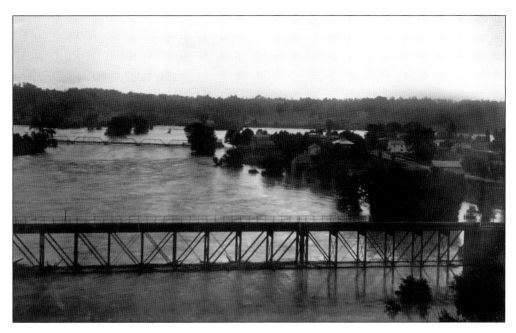

Portageville's location along the river also proved to be a source of trouble. Floods, like this one in July 1902, periodically ravaged parts of the town. Lillian Bull documented the flood of 1902 in her scrapbook. "Our village is a track of ruin . . . The water in the Genesee overflowed its banks and came into the streets to a depth of from six to ten feet . . . the iron bridge is condemned and is carefully watched . . . The loss of property cannot yet be estimated but it is heavy." The iron highway bridge, partially submerged, is visible in the distance in the upper photograph. In the foreground the floodwaters have almost covered the piers of the railroad bridge. The photograph below shows a view looking down Hamilton Street toward the river that covers the east end of the street. (Both Seymour/Cottrell family.)

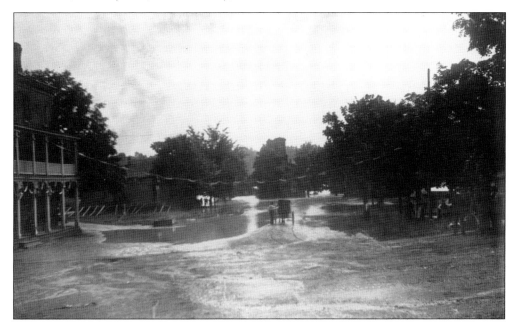

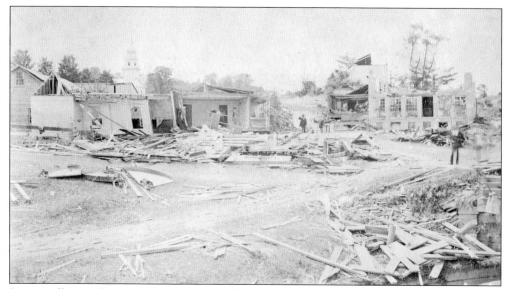

Portageville was also struck by a tornado. Although some stories say it happened in 1875 or 1877, the actual date was July 4, 1876, the day of America's centennial celebration. Most of the town's residents were at the dance grove near the Cascade House when the storm hit a little after 2 p.m. It only lasted a few minutes, but the tornado ripped down the main part of the community and destroyed everything in its path. A boy named Maston was killed and several others were injured, including Byron Payne, who had been caught in his outhouse. The stone mill, barns, and several buildings were heavily damaged or destroyed. Robert Rae lost the roof to his house, his entire barn, and a pig. Shingles from Portageville's roofs were found as far away as Nunda. The photograph above, taken shortly after the tornado struck, documents the devastation. Remarkably, the Universalist Church, not far from the storm's path, was spared. The church's undamaged steeple can be seen in the upper left. The image below shows the damage below the canal near the Hamilton Street Bridge. (Above, Genesee Falls Town Historian; below, author's collection.)

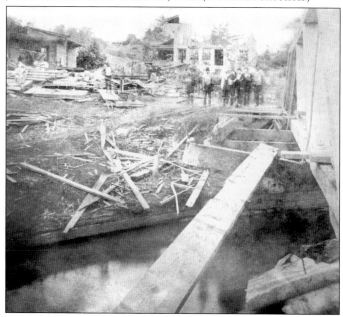

The greatest threat that Portageville ever faced, however, was man-made. In the 1890s, plans were laid to tap the power of the Genesee River to make electricity. An 1896 survey recommended that this storage dam be built between Portageville and the Portage Bridge. The result would be a man-made lake stretching more than a dozen miles to the south. Portageville would drown.

A local reporter wrote, "Imagine Portageville inundated with water to a depth of seventy-six feet higher than the highest chimney on Joyce's Genesee Falls hotel. This is not an improbability but rather a possibility of the future." The Genesee River Company, organized to build the dam, had the power and influence to complete the project. Only William Pryor Letchworth stood in its way. (New York State Archives.)

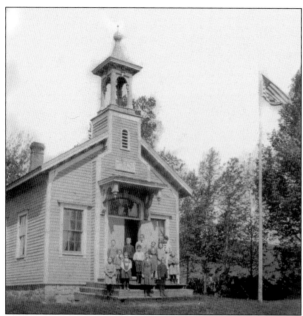

William P. Letchworth had been an active citizen in the township since his arrival in 1859. Letchworth, for example, provided the land and money to build Genesee Falls District School No. 2, which was often called the Letchworth School. The Swyers children, whose family worked Letchworth's Chestnut Lawn farm on shares, attended the school. This photograph may have been taken around 1910, the year of Letchworth's death. (Swyers family.)

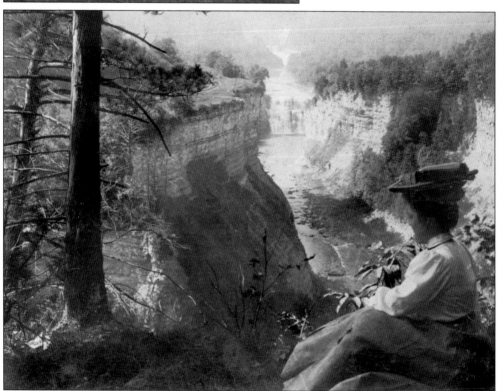

A woman gazes from Inspiration Point in the summer of 1907. Faced with the continued threat from the Genesee River Company, Letchworth offered his Glen Iris lands to New York state, leading to the creation of Letchworth State Park in January 1907. With the endangered falls and surrounding lands now in public hands, the Genesee River Company faced an uphill battle. The dam project finally died in 1913.

Tourists visit the park's museum around 1920. The museum had been built in 1913 to serve as a new attraction to visitors. Park officials reported more than 800 automobiles a week during the 1919 season. Some of them found their way to Portageville, for the *Nunda News* reported in 1918 that "Several automobile parties are stopping at the Genesee Falls Hotel after visiting scenery at the Park." (Town of Nunda Historian's Office.)

William P. Letchworth's home was converted to the Glen Iris Inn in 1914. By the end of the decade, the Glen Iris was serving more than 8,000 dinners and accommodating 1,600 lodgers. Many overnight guests had to be turned away because of limited rooms. It is likely that these unidentified guests, posing on the Glen Iris lawn in June of 1938, had stopped in Portageville.

There were other economic benefits of having a popular state park nearby. Many seasonal employees were local folks and local businesses provided goods and services the park needed. This was especially true during the Great Depression when the CCC camp at Lower Falls, shown here, provided the area with both work and business. During World War II, the camp held German prisoners of war. (Castile Historical House.)

Letchworth State Park's administration building was in the old McCarthy House on Trout Pond Road. In March 1946, the building was destroyed in a fire. Fire companies from Genesee Falls and Castile are shown here responding to the fire. The small garage to the right is still standing in the park. (Swyers family.)

A significant shift was taking place in the Genesee Falls economy. Tourism seemed to be the future. "Portageville, Resort Center, Mecca for Tourists, Views Future with Confidence," proclaimed the *Nunda News* in 1946. "Portageville promises to become even more popular in the days ahead as the beauties of this resort center become better known to travelers and oncoming generations." Leo Beardsley's Log Cabin Inn, shown above in 1938, stood across the road from the Portageville Entrance to the park. Known locally as Slab City, one could buy gas, baked goods, beer, and a 25¢ fish fry. The business moved to the southern edge of Portageville where it later became Ralph Myarcle's Letchworth Court, shown here in 1952. Boxer Joe Louis visited the Court in 1955. Today, as Letchworth Pines, the business continues as a popular bowling alley and restaurant. (Both Genesee Falls Town Historian.)

One local landmark was not about making money. John Dumbleton poses next to his "Bottle Tree" in the early 1950s. Years earlier, he had started placing bottles on the branches of a tree in front of his house. By the time of his death in 1962, Bottle Tree Farm was a famous landmark for travelers along Route 19A. The tree fell during an ice storm in January 1998. (John Fusco.)

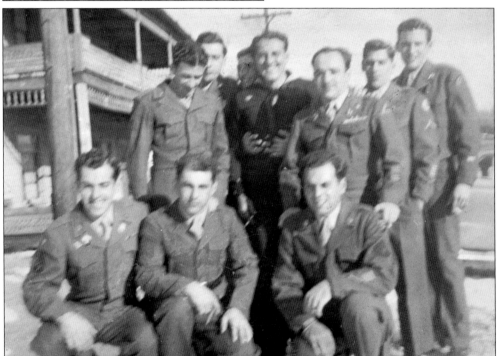

More than 40 local men served in World War II. Brothers Robert and Leon Lathrop were killed in action. Some returning veterans posed for this snapshot when they gathered for the feast their grateful families held for St. Joseph in 1946. From left to right are (first row) Joe Vasile, Mario D'Angelo, and Anthony R. Vasile; (second row) Anthony T. Vasile, Frank Farraro, and William Oliver; (third row) Thomas Vasile, Sam Vasile, Sam D'Angelo, and John Brogan. (Mary Colombo.)

Portageville's restaurants and bars prospered in the postwar years, especially with several of the surrounding towns going "dry." One popular place was Modesto "Augie" Oliver's Sunny Side Restaurant next to the river bridge. Shown here in 1934, the building had expanded by 1946. The fact that many local bars were popular with the town's young men concerned a man named David D. Kennedy. (Genesee Falls Town Historian.)

David D. Kennedy had been the head of the Foote Company in Nunda all through the war. Although not a native, he loved Portageville and lived in a suite of rented rooms on the third floor of the Genesee Falls Hotel. Determined to give young folks something to do, he was instrumental in creating Kennedy Field, part of the Portageville Recreation Center. (Mary Colombo.)

Fr. Joseph O'Connor speaks during the dedication of Kennedy Field in September 1946. Seated on the bench behind him are *Nunda News* owner Walter B. Sanders (right) and David Kennedy. The newspaper reported it was "a fitting climax to all who had a part in making Kennedy field . . . a place Portageville young people can call their own." The field was beyond Hamilton Street, next to the river. (Town of Nunda Historian's Office.)

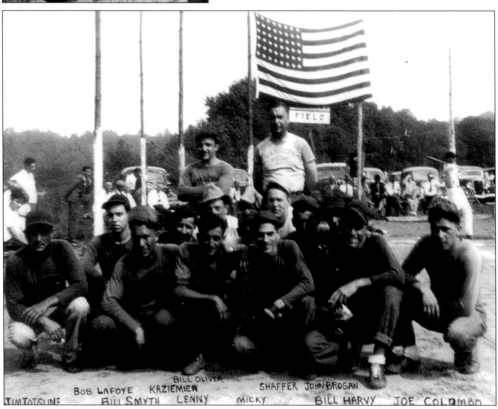

Members of the Portageville softball team pose on Kennedy Field in the late 1940s. Team member Joseph Colombo (first row, far right) recalls that the team played and beat most other town teams. David Kennedy left the area after his retirement in 1954 and died in 1963. The Genesee River has claimed Kennedy Field, but the name David D. Kennedy is still fondly remembered in the town. (Joseph Colombo.)

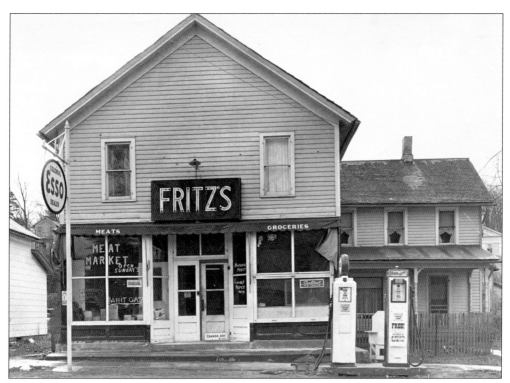

Small town life was changing throughout America, and Genesee Falls was no exception. Although more visitors came to Letchworth State Park every year, the park had expanded northward to Mount Morris. New campgrounds, overlooks, and recreation centers were built mostly in the northern park, drawing tourists away from Portageville. But the Genesee Falls Hotel, now owned by the Williams family, still attracted visitors. People still needed groceries as well, and Fritz's store was the place to go. Situated on Main Street west of the post office, John Fritz offered both gas and groceries. The building still stands today. These two photographs were taken in November 1950. (Both Genesee Falls Town Historian.)

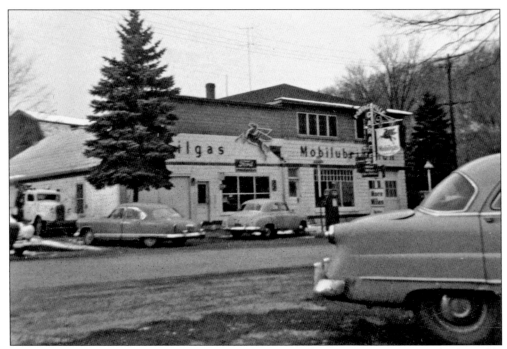

The same 1946 *Nunda News* article that touted Portageville's tourism potential spoke favorably of the town's supervisor Andrew J. Reitschky. Reitschky served as supervisor from 1940 to 1955. He is also remembered for his garage near the river bridge on the west side of Main Street, seen in this Roy Gath photograph from the 1940s. Almost 30 years later, the Portageville Garage was destroyed in a historic flood. (Nunda Historical Society.)

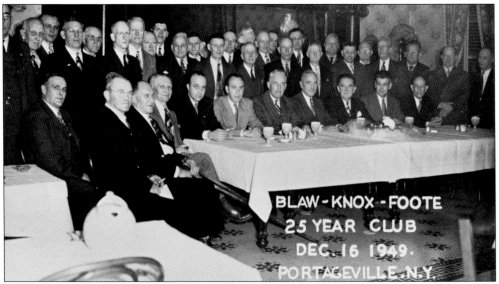

"Portageville citizens view the future with confidence and optimism," stated the *Nunda News* in 1946. That hopeful vision was likely shared by David Kennedy (seated third from right) and other area men gathered at the Genesee Falls Hotel in 1949. They and other residents of Genesee Falls, Portage, and Nunda, could not foresee the vast changes and challenges that awaited their towns in the years to come. (Nunda Historical Society.)

Five

MODERN TIMES

1950s–PRESENT

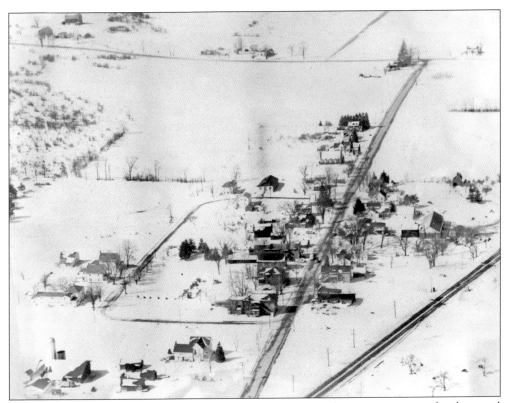

Winter snows coat the hamlet of Hunt in the early 1960s. Modern times were not kind to rural America. Economic, social, and demographic shifts pulled many of the young workers to cities and suburbs. Large chain stores, malls, and large-scale agribusiness practices buried many of the mom-and-pop businesses and family farms that had flourished in the communities of Nunda, Portage, and Genesee Falls. (Portage Town Historian.)

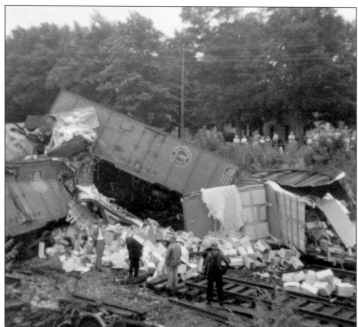

Railroads, long a part of the fabric of each town's life, provided plenty of memories. Nunda's Sesquicentennial Celebration was in full swing in August 1958 when a train derailed near Dalton's station. Roy Gath's photograph of the wreck shows the crowd looking over the hundreds of cases of tuna fish that spilled from wrecked freight cars. Lots of tuna fish was served in area homes after the wreck. (Nunda Historical Society.)

The growing number of cars, trucks, and interstate highways brought an end to the railroad era. Station agent Leon Smith sits at his desk for the last time on June 15, 1959, the day the Dalton railroad station closed. Although the train whistle is still heard in Nunda, the trains no longer stop in the town. The Dalton depot was torn down in the fall of 1966. (John Fusco collection.)

The Pennsy still came to the village of Nunda for a few years. The last freight car, shown here, arrived on March 13, 1963, with materials for the Nunda Lumber Yard. Soon the line was abandoned, the tracks were removed, and the old depot on Second Street was torn down. Today, much of the abandoned line is a recreational trail known as the Genesee Valley Greenway. (Town of Nunda Historian's Office.)

Nunda, Portage, and Genesee Falls began to lose many of their major industries. Foote Manufacturing Company became a subsidiary of the Blaw-Knox Company in 1948. The plant continued to manufacture road pavers for several years but closed its doors in 1955. Although some of the original building has been torn down, much of the plant is still in use on State Street today. (Nunda Historical Society.)

Hugh Slawson started Slawson's Sawmill near Hunts Hollow in the summer of 1933. The business weathered the Depression, several recessions, and some major fires, including one in May 1972 that destroyed the main mill. In 1977, the sawmill was the town of Portage's largest employer and only industry. The Slawson family sold the mill in 1982. The mill closed in July 2007. (Nunda Historical Society.)

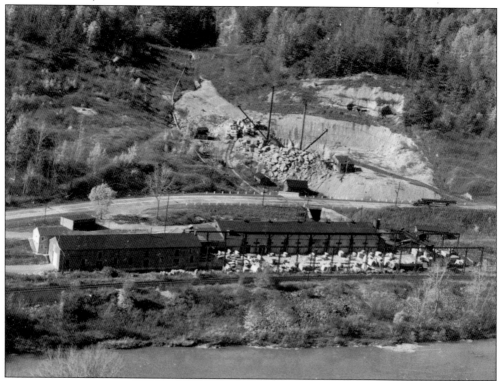

This photograph of the American Bluestone Company quarry in Genesee Falls was taken in 1954. The Genesee River is in the foreground with the railroad loading yard just beyond. The actual quarry lies across the highway. The Portageville bluestone quarry—the economic mainstay of the area for more than a century—closed in the late 1960s. Some traces of the operation can still be found. (Seymour family.)

Many local landmarks were lost to fires, decay, or the economic realities of modern times. The Nunda House (page 17) was the home of the Peter DePuy Bank and Fox Hotel through most of the 20th century. Roy Gath's 1962 photograph shows the old building being demolished to make way for the bank building that stands on the corner of State and Portage Streets today. (Nunda Historical Society.)

The Universalist Church (center) and the Presbyterian Church (right) stand along Nunda village's East Street in this c. 1910 image. The Presbyterian Church, built in 1847, closed in 1979 and was torn down. The village gazebo and park now occupy that spot. The 1874 Universalist Church closed in the 1940s. Partially destroyed by fire in 1961, the building is now an automobile parts store. (Nunda Historical Society.)

Natural disasters have continued to take their toll in modern times. The greatest of these was the flood caused by Hurricane Agnes in June 1972. Old-timers had seen the river reach the 19-foot flood stage several times, but no one had ever seen the river at the 35.25 feet it reached on June 23. These photographs of the flood by David Hurd were taken on June 22. Above, Vera Clancy Hurd and her son Todd watch as the river flows through the first floor of the Genesee Falls Inn. That very morning, the new owners of the inn, the Wheeler family, had closed on the hotel. The photograph below looks along Main Street toward the submerged river bridge. The Mobil sign at left marks the location of the Portageville station (page 112) that was destroyed by fire on the first day of the flood. (Both A. David Hurd.)

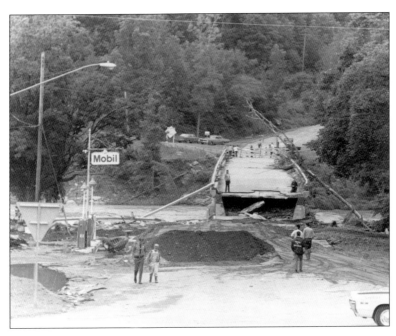

In addition to the destruction of the Portageville gas station and the heavy damage to the old hotel, flood waters also ravaged 10 houses, John Milillo's TV and Repair Shop, the town hall, and the river bridge, shown above. The image below shows another bridge that was destroyed in the flood. Whiskey Bridge had crossed the Genesee River south of Portageville. Originally known as Prentice Bridge, it earned its nickname when liquor bound for the "dry" town of Portage was hidden there. Standing on the wreckage of Whiskey Bridge are, from left to right, David Hurd, Todd Hurd, Beverly Fisher, and Theresa Hurd. The new bridge on the site is still known as Whiskey Bridge. The Portageville Bridge was also repaired. (Both A. David Hurd.)

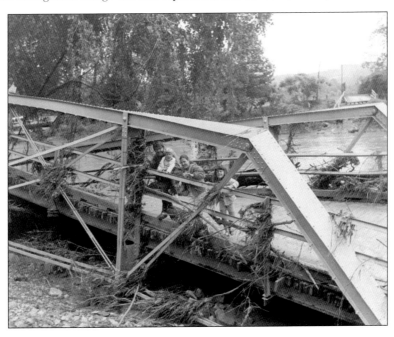

World events have also touched the towns. Local residents served in the Korean and Vietnam Wars, and Iraq. Army Pfc. Arnold Duryea (left) grew up in Oakland and graduated from Nunda Central School in 1966. He was killed in action in Vietnam on February 9, 1968, and buried in Oakland Hill Cemetery. Not long after, Billy Donovan entered kindergarten at Keshequa Central School, which was created in the summer of 1968 by the merger of the Dalton and Nunda school districts. After graduating from Keshequa in 1982, Donovan entered the Annapolis Naval Academy and became a decorated navy flyer. Commander William H. Donovan was killed in the Pentagon on September 11, 2001. Gerald Barkley's photograph below was taken in front of the school during the June 2002 dedication of the Donovan Memorial. (Left, Duryea family; below, Nunda Historical Society.)

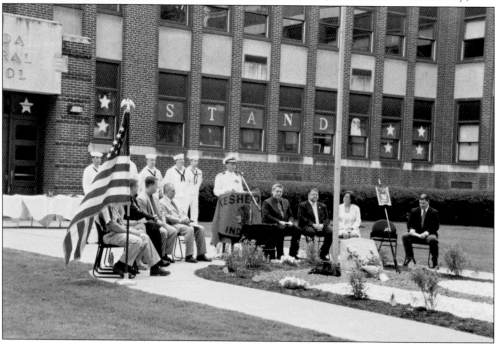

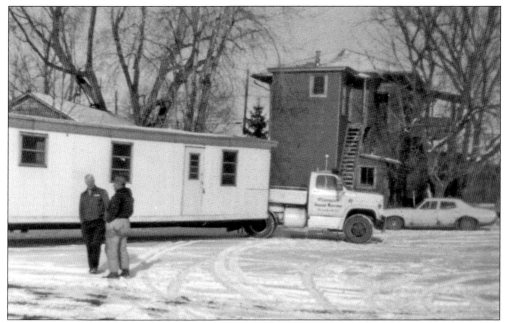

Sometimes the new sweeps away the old. In this 1985 photograph, a temporary post office is being set up in Hunt. The Grange Hall, seen beyond the truck, was soon torn down to make way for the permanent post office now located there. The Hunt Grange was a victim of modern times. Once a strong and vibrant rural organization, it disbanded in 1990. (Town of Portage Historian.)

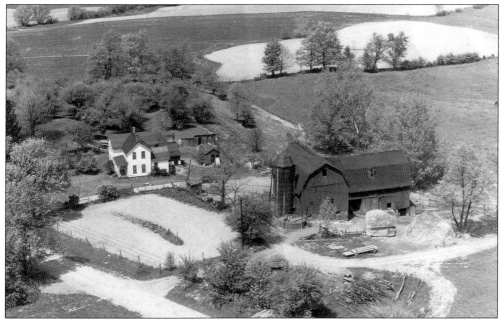

The loss of small family farms helped lead to the demise of local granges. Once it was common to see farms like the Thompson farm in Portage, shown here in the 1940s. But increased costs, regulations, and competition brought about their decline. The remaining farm houses and barns are important parts of the historical landscape. The Allen Thompson farm became a century farm in 2007. (Allen Thompson family.)

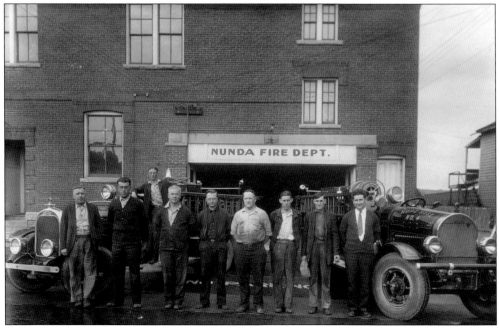

Often the old adapts to new times. Through most of the 20th century, Nunda's fire department consisted of the two fire companies shown in this 1959 photograph: Nunda's Neptune Hook and Ladder No. 2 and Hope Hose Company No. 4. The companies merged in 1968 to form the Nunda Fire Department, which, along with the Nunda Ambulance Service, still proudly serves the area. (Town of Nunda Historian's Office.)

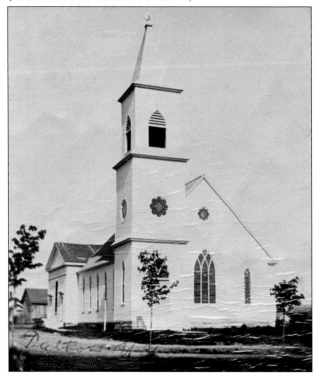

Churches have also adapted. The Dalton United Methodist Church, organized in 1858, is part of a faith community with Methodist churches in Nunda and West Sparta. Like other churches in the three towns, the Dalton church is an active member of the local community and sponsors several organizations and activities. This photograph shows the church in the late 19th century. (Nunda Historical Society.)

The Nunda Lumber Yard and McMaster's Garage in Nunda have lasted more than 70 years. Once Again Nut Butter was established in 1976 and purchased the former Piper & Paine building in 1981. An employee-owned company specializing in nut butters, it has prospered in one of Nunda's remaining factory buildings. Compare this 1983 photograph of the building interior with the one on page 56. (Once Again Nut Butter.)

Other buildings have been preserved. Nunda's Livingston House and Portageville's Genesee Falls Hotel are currently being renovated. Nunda's Union Block, seen here during a 1962 Memorial Day parade, was saved from demolition and is under restoration. The marching band is the Nunda's Rancheros. Formed in 1958, the drum and bugle corps won awards into the 1970s. They reunited in 2008 for Nunda's bicentennial parade. (Nunda Historical Society.)

Many historical houses still serve as homes for local families. Portage's Edgerly residence, seen here in the 1960s, is on the National Register of Historic Places. The main house was built about 1828 by David Edgerly. Local lore connects it with the Underground Railroad. Many other early houses, including the area's two cobblestone houses (page 105), still stand. New homes have also been built in all the towns. (Mary Barr.)

The Universalist Church of Portageville is among the oldest in Wyoming County. Built in 1841, the flourishing church fell onto hard times during the 20th century. The Portageville Chapel, a not-for-profit organization, acquired the property in 2007 to create "a place of rest and renewal for professional organists." The church's restoration and public concerts have contributed to a sense of renewal for the area. (The Portageville Chapel Retreat for Organists.)

Nunda Fun Days has been held since 1965. It is a celebration of small town life, with many local groups taking part. Bell Memorial Library has its annual book sale, the Kiwanis and Rotary clubs and the chamber of commerce have booths, and local high school classes host dinners. The Saturday parade, shown here in 1965, still draws participants and spectators from miles around. (Nunda Historical Society.)

Each town has had its own celebrations. Portage's 1977 sesquicentennial celebration included a parade down the Main Street of Hunt that was reminiscent of the one in 1911 (page 67). Among the participants was local farmer Bryon Thompson, pulling one of the floats. (He also appears on page 79 first row, third from right.) Although Thompson died in 1991, his descendants are still proud of their Portage roots. (Portage Town Historian.)

Genesee Falls' sesquicentennial was held in 1996. The celebration was especially important to residents who had not only experienced the flood of 1972 but also had successfully fought a revived plan to build a dam near the Portage Bridge in the late 1960s. The burial of a time capsule to be opened in 2046 was an affirmation of their belief in the survival of their town. (Town of Genesee Falls.)

Newlyweds Joel and Melissa Stevens (far left) ride in Nunda's bicentennial parade in July 2008. Married just before the parade began, they joined the march down East Street. Their wagon leaves the village square as they head toward their new life. Like those of earlier generations, the Stevenses and their descendants will help to write the continuing story of Nunda, Portage, and Genesee Falls. (Stevens family.)

BIBLIOGRAPHY

Beauchamp, William M. *Aboriginal Occupation of New York*. Albany, NY: University of the State of New York, 1900.

Breslin, Thomas A., Thomas S. Cook, Russell A. Judkins, and Thomas C. Richens. *Letchworth State Park*. Charleston, SC: Arcadia Publishing, 2008.

Byrnes, Thomas E. *Two Centuries of Medical Care in the Town of Nunda and Vicinity*. Nunda, NY: Town of Nunda Bicentennial Committee, 2008.

Cook, Thomas S. *Yesterday . . . Stories from Old Nunda*. Nunda, NY: Town of Nunda Bicentennial Committee, 2008.

Dalton Historical Cookbook. Dalton, NY: United Methodist Church, 1982.

DePuy, Hope, and Sally Hall. *Churches in the Town of Nunda and Vicinity*. Nunda, NY: Town of Nunda Bicentennial Committee, 2007.

Doty, Lockwood L. *A History of Livingston County NY*. Genesee, NY: Edward E. Doty, 1876.

Genesee Falls Sesquicentennial Committee. *Town of Genesee Falls, Portageville NY, 1846 150 Years 1996*. Fillmore, NY: Big Tree Graphics, 1996.

Hand, H. Wells. *Centennial History of the Town of Nunda, 1808–1908*. Interlaken, NY: Heart of the Lakes Publishing, 1993.

History of Wyoming County NY with Illustrations, Biographical Sketches and Portraits of Some Pioneers and Prominent Residents. New York: F.W. Beers & Co., 1880.

Kipp, David L. *Locking the Heights: The Rise and Demise of the Genesee Valley Canal*. 1999. www.letchworthparkhistory.com

Nunda News. 1859–1982.

Smith, James H. *History of Livingston County New York*. Syracuse, NY: D. Mason & Co., 1881.

Thompson, Elizabeth. *Sesqui-Centennial Town of Portage Livingston County New York State 1827–1977*. Town of Portage Sesquicentennial Committee, 1977.

www.arcadiapublishing.com

Discover books about the town where you grew up, the cities where your friends and families live, the town where your parents met, or even that retirement spot you've been dreaming about. Our Web site provides history lovers with exclusive deals, advanced notification about new titles, e-mail alerts of author events, and much more.

Find Your Place in History.